IMAGES
of America

LOST DALLAS

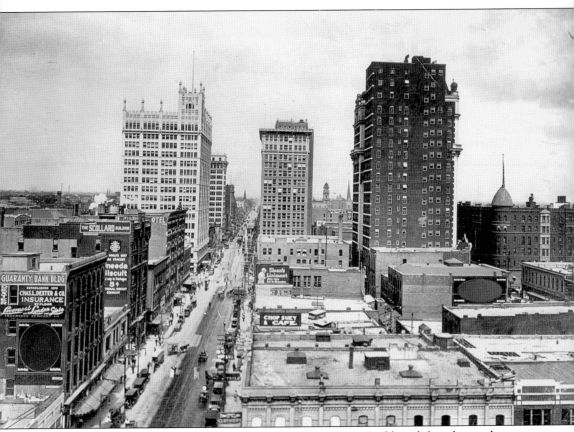

The Guaranty Bank Building, Imperial Hotel, and Praetorian Building define the northern street wall of Main Street in this 1915 image. Looking east, the beloved bell tower of the US Post Office Building is visible between the Southwestern Life Building and the back facade of the Adolphus Hotel. The distinctive tower of the Imperial Hotel stands watch directly across Commerce Street. (Courtesy of the Dallas Municipal Archives.)

ON THE COVER: One can only imagine what this young gentleman was doing on the roof of the Baker Hotel as he gazed west over the burgeoning business district. No doubt he was marveling at the wondrous buildings that lined downtown streets in 1925, including, from left to right, the Waldorf Hotel, the Linz Brothers Building, and the Southland Hotel. (Courtesy of California Museum of Photography/Keystone-Mast Collection.)

IMAGES
of America

LOST DALLAS

Mark Doty

ARCADIA
PUBLISHING

Published by Arcadia Publishing
Charleston, South Carolina

Printed in the United States of America

Library of Congress Control Number: 2011941988

For all general information, please contact Arcadia Publishing:
Telephone 843-853-2070
Fax 843-853-0044
E-mail sales@arcadiapublishing.com
For customer service and orders:
Toll-Free 1-888-313-2665

Visit us on the Internet at www.arcadiapublishing.com

*To the wonderful and maddening city of
Dallas, which I have grown to love*

CONTENTS

ACKNOWLEDGMENTS

First, I would like to thank my fellow City of Dallas employees and authors for their immeasurable time, effort, and memory while completing this book—John H. Slate, city secretary's office and municipal archivist; Sally Rodriguez and Willis Winters in the parks and recreation department; Troy Ogilvie in the water department for his scanning skills; Carol Roark and her amazing staff at the Texas/Dallas History and Archives Division, Dallas Public Library; and Tammy Palomino in the city attorney's office for her advice in regards to this particular endeavor.

Second, I would like to thank the following for allowing me access to their personal collections: Larry Good, Craig T. Blackmon, Marcel Quimby, Kate Singleton, and Mark Rice.

Third, much gratitude to fellow authors Michael Hazel, Sam Childers, Denise "Inez" Alexander, and especially Brian "Pedro" Davis, for his suggestions and encouragement.

Also, thanks to my family and friends—with a special note to Chris Andersen, Nate Payne, Mike Thatcher, Darin Sanders, Brian Chaffin, Michael Maples, and Greg Brown—for their support and encouragement.

Unless otherwise noted, photographs and images appear courtesy of the Dallas Municipal Archives. Other collections noted include Katherine Seale and the Preservation Dallas collection; Dallas Heritage Village, with a special thank-you to Evelyn Montgomery and to Sam Montgomery for his willingness to scan a lot of postcards on his winter break; Gerry Cristol and Temple Emanu-El; the Bywaters Special Collection and Mary McCord/Edyth Renshaw Collection on the Performing Arts, Hamon Arts Library, Southern Methodist University, Emily George Grubbs and Ellen Niewyk; and the *Dallas Morning News*, with an unyielding gratitude to Jerome Sims for allowing me unlimited access to the extensive *DMN* collection.

And finally, thanks to the city of Abilene, Texas, where I first learned to love a city's past and believe in the importance of its preservation.

INTRODUCTION

Founded in 1841 by John Neely Bryan, a Tennessee lawyer, the city of Dallas was blessed from day one with an entrepreneurial desire to become the next great city not only of Texas but of the United States. After it was determined that the nearby Trinity River was not suitable for riverboat or commercial shipping purposes, the city leaders made sure that the fledging community would benefit from the next best assurance of prosperity: railroads.

When Dallas found itself at the crossroads of two major railroads, the north-south Houston & Texas Central and the east-west Texas & Pacific, the small town exploded commercially and began to attract many industries as well as people. The population swelled to over 100,000 by the 1900s, and wave upon wave of new construction pushed the city limits further east, north, and south. With the annexation of Oak Cliff, an incorporated town across the Trinity River from downtown, Dallas's growth in all directions became unchecked.

With each new wave of construction, older buildings from antebellum and early-1900s Dallas were bulldozed. Large swaths of downtown blocks and sometimes entire neighborhoods were lost to the seemingly unquenchable appetite for newer and better.

"Keep the dirt flying" became Dallas's unofficial city motto, even during the lean years of the Great Depression and World War II. This growth continued well into the 1960s and quickly accelerated again from the mid-1970s through the 1980s. During the 1970s and 1980s, though, a grassroots effort began to salvage and protect what historic architecture was left downtown and in the original "streetcar suburbs" that ringed the central business district. With the creation of the City of Dallas preservation program in March 1973, along with the passage of the first historic district, Swiss Avenue, attention was drawn to quickly disappearing historic resources.

While there are still quite a few monumental and important historic structures left downtown, along with sizable residential neighborhoods that enjoy historic designation and protection, those buildings and sites that have been lost forever to the bulldozer are numerous and still mourned in the present.

This book is to serve not only as a gentle lament for what has been lost but also as a realization of what still survives and continues to flourish.

One

WEST END

This April 1885 Sanborn Fire Insurance map illustrates how John Neely Bryan laid out the town to be named Dallas over 40 years earlier. The courthouse, in the block bound by Houston, Main, Jefferson (renamed Record), and Elm Streets, was located on land donated by Bryan. Street names such as Water, Broadway, Polk, and Carondolet have disappeared from the local lexicon.

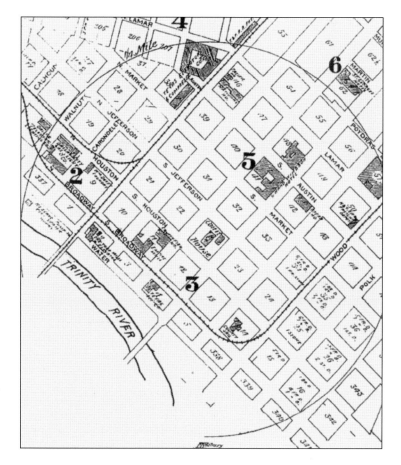

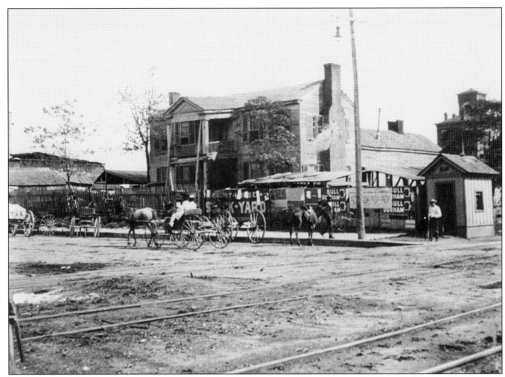

Built in 1858 on the location of John Neely Bryan's third log cabin, the Greek Revival residence of Alexander and Sarah Horton Cockrell stood at the southwest corner of Commerce Street and Broadway. Sarah Horton Cockrell, who married Alexander in 1847, managed and expanded his multiple enterprises after his death in 1858. The handsome two-story house with a double gallery front porch was damaged in the flood of 1908 and subsequently torn down. (Courtesy of the *Dallas Morning News*.)

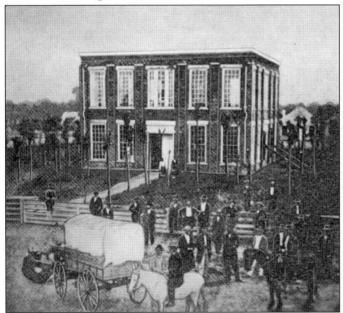

Mayor John Jay Good helped design this square brick building to serve as the third courthouse for Dallas County, replacing a two-room log cabin in 1855. A survivor of the 1860 fire that devastated most of the business district, it was torn down in 1871, and its materials were sold for $465. The location of the courthouse, as indicated on John Neely Bryan's 1850 map of Dallas, led to the creation of a business and office district around the square. (Courtesy of Nathan Payne.)

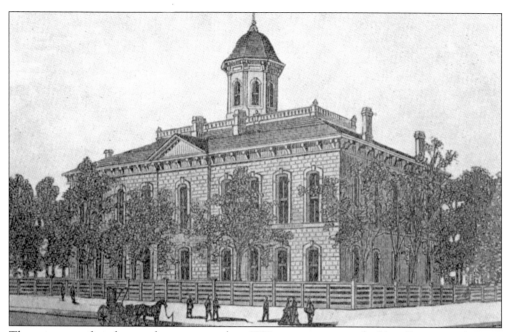

The two-story fourth courthouse, started in 1871, was constructed of locally quarried stone. Despite severe cost overruns, including intervention by the state legislature, the structure was completed in 1874, only to partially burn in 1880. The stone shell remained in place. (Courtesy of Nathan Payne.)

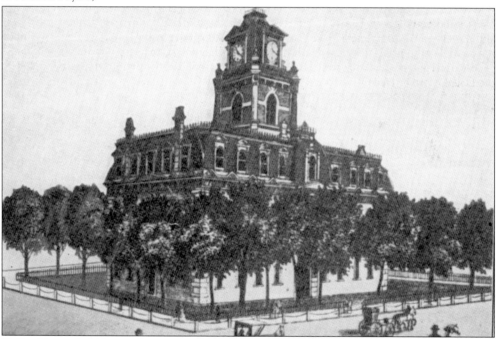

Dallas County's fifth courthouse was designed by the city's leading architect, James Flanders, in 1881. Flanders utilized the existing stone walls of the previous courthouse to design a Second Empire–style building with looming clock tower and mansard roof. Though widely touted as being fireproof, this structure burned in 1890. (Courtesy of Nathan Payne.)

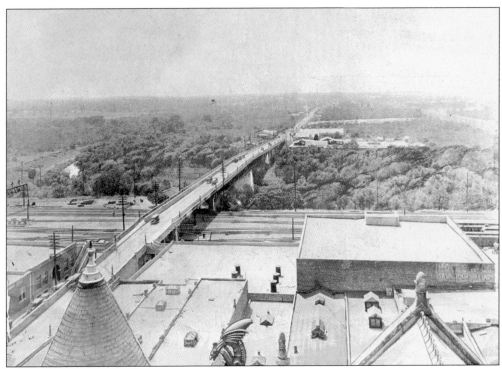

This 1925 photograph—taken from the tower of the sixth Dallas County courthouse, looking west—indicates how close the river bottomland of the old Trinity River channel was in relationship to the growing business district. In the foreground are the roofs of buildings demolished for the triple underpass as well as the old Commerce Street viaduct. The Trinity would be moved and contained within levees as a flood control measure during the 1930s. Visible in the lower center of the image is a gargoyle perched on the courthouse roof. (Courtesy of the *Dallas Morning News*.)

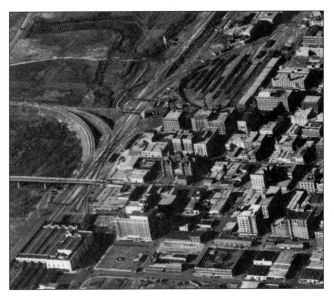

An 1933 aerial photograph shows the original configuration and built environment as laid out by the 1850 Bryan plat map before the construction of the triple underpass and Dealey Plaza. Envisioned by George Bannerman Dealey, editor of the *Dallas Morning News*, as a grand entrance to Dallas, the Works Progress Administration (WPA)–constructed vehicular park designed by architects Hare and Hare of Kansas City would be completed in 1941. (Courtesy of Park and Recreation Collection/ Dallas Municipal Archives.)

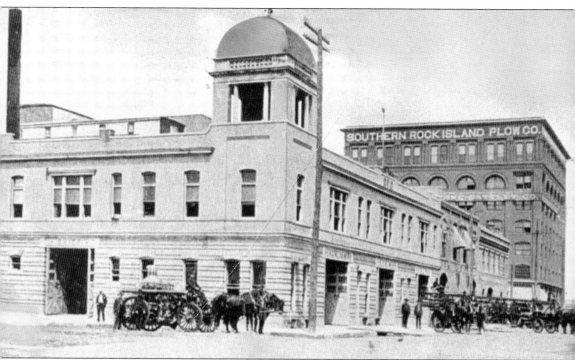

This fire station, located on Houston Street between Main and Elm Streets, was considered a model for the city's growing department. The two-story masonry building, with its corner tower, also shared the block with the headquarters for the Dr. Pepper Bottling Company. The entire block would be leveled in 1934 for the creation of the triple underpass, which opened in 1936. The Southern Rock Island Plow Company building in the background would later gain notoriety as the Texas School Book Depository. (Courtesy of the *Dallas Morning News*.)

The stretch of Main Street between Market and Record Streets contained a fine collection of late-19th-century structures, including the Ash and Wagner building, on the far right of the block across from Dallas's sixth courthouse, more well known as Old Red. This block, along with the one across Main Street, was cleared in 1966 for the John F. Kennedy Memorial Plaza.

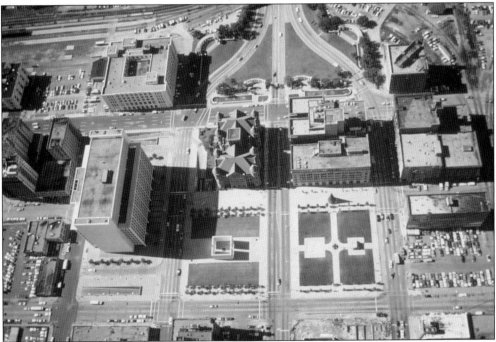

To accompany the John F. Kennedy Memorial Plaza and its Philip Johnson–designed memorial cenotaph, the Dallas County Historical Plaza was created to provide a place for John Neely Bryant's log cabin, moved from the grounds of Old Red courthouse across Main Street. Various historical markers as well as a large terrazzo map of Dallas County were located in the plaza. The park, with its symbiotic symmetry to the memorial across the street, was torn out to accommodate an underground parking structure and replaced with a nondescript substitution in 2006.

Land was purchased in September 1946 for use as an access roadway and esplanade for a proposed west entry to the Union Station terminal located on Houston Street, creating Union Terminal Park. The park's amenities included baseball diamonds and a small park building. Union Terminal Park only lasted until 1956, when the Texas Turnpike Association chose the site and neighboring land for a new section of Interstate Highway 35. (Courtesy of Park and Recreation Collection/ Dallas Municipal Archives.)

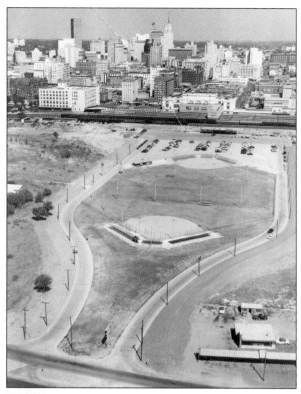

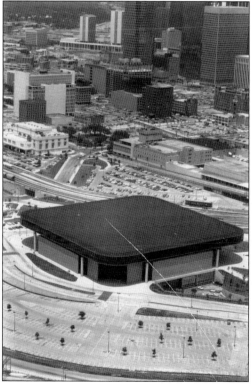

Completed in 1980, Reunion Arena, named after the mid-19th-century La Reunion commune located across the Trinity River in Oak Cliff, was the main indoor venue for the Dallas sporting community. Home to the Dallas Mavericks basketball and Dallas Stars hockey franchises, the large structure hosted an NBA All-Star game, NCAA basketball games—including a Final Four—concerts, campaign rallies, the 1984 Republican National Convention, and wrestling. Reunion Arena was used sporadically after the new American Airlines Center was built in the Victory neighborhood in 2001, and on November 17, 2009, after months of interior demolition work, the remains of the structure were finally imploded. (Courtesy of the *Dallas Morning News*.)

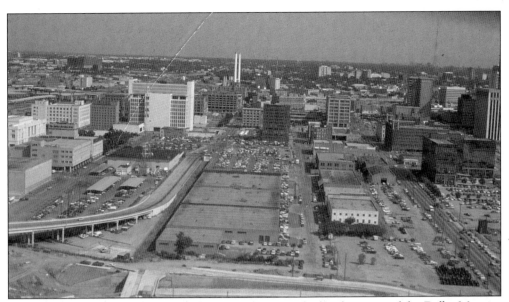

This aerial view of the south end of downtown between the headquarters of the *Dallas Morning News*, Jefferson Street viaduct, and Interstate Highway 30 was taken in the 1980s. The majority of the one-story buildings and parking lots in the immediate foreground would be demolished and replaced by multiple expansions of the Dallas Convention Center in 1993. Portions of the southern end of the West End National Register Historic District are visible in the center of the image.

Dominating the surrounding neighborhood of Boggy Bayou when built in 1888, the Texas Farmer's Alliance Exchange was a four-story brick structure at the southwest corner of Market and Wood Streets designed by architect Albert Ullrich. The elaborate Queen Anne building also served as Dallas County courthouse for a short time in 1890. The striking building survived until 1922, when it was lost for a parking lot. (Courtesy of the *Dallas Morning News*.)

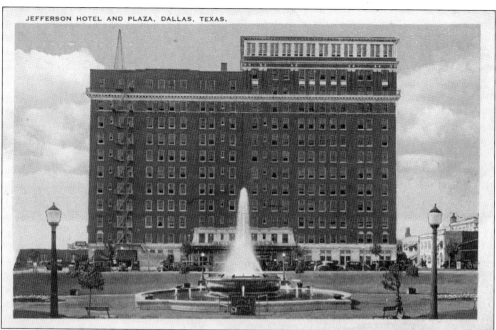

Opened in October 1917, the Hotel Jefferson was state of the art for its time, including one floor dedicated exclusively for women. Expanded in 1919, the prominent Hotel Jefferson and later Dr. Pepper rooftop signs greeted travelers looking for clean and comfortable lodging after exiting the Union Station terminal, located across Houston Street. Remodeled and renamed the Hotel Dallas in 1953, the landmark building that defined the northern edge of Ferris Plaza was taken down in May 1975. (Courtesy of Dallas Heritage Village.)

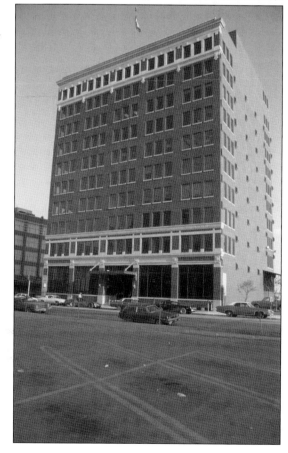

Sam Perkins built this structure in 1925 to accommodate his burgeoning dry goods business at the southwest corner of Austin and Jackson Streets. Increased in height to 10 stories, the Perkins Building was purchased in 1955 to serve as headquarters for States General Life Insurance Company. The redbrick structure with accents was restored in 1981 and was a contributing structure to the West End National Register District. The Belo Corporation purchased the building in 1996 and leveled it in April 2001.

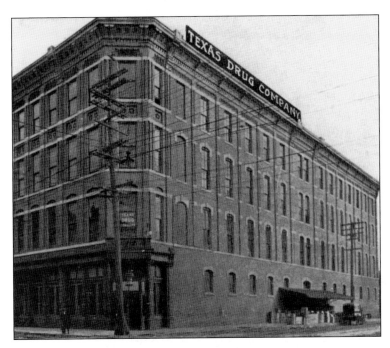

Built in 1884 by A.B. Bristol as the Blankenship and Blake Mercantile Warehouse, this building housed Texas Drug Company by 1904. The four-story masonry building with a pressed metal cornice was located at the corner of Commerce and Lamar Streets. The building was stuccoed over and suffered other minor alterations over the subsequent decades.

Later known as Victor Costa's, this building, along with the Wholesale Merchants Building next door at 912 Commerce Street, survived until November 1982, when the structures were imploded after a months-long battle for designation for a commercial high-rise project that never materialized.

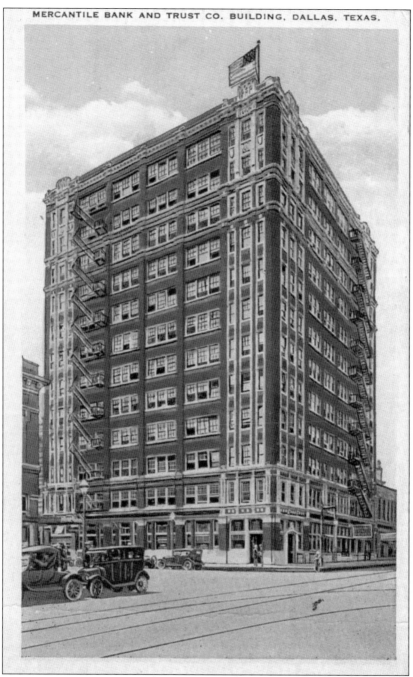

MERCANTILE BANK AND TRUST CO. BUILDING, DALLAS, TEXAS.

This 12-story redbrick building with terra-cotta detailing on the top three floors was erected in 1920 at 810 Main Street. Over the span of its lifetime, it served as quarters for the Dallas County State Bank and the Texas Bank and Trust Company, where it received its familiar moniker. With the blessing of the Landmark Commission and city council, the Texas Bank Building crumbled to the ground in less than 30 seconds after being imploded on Sunday, May 23, 1982. The site today is a parking garage with a gym on the 15th floor ironically named the Texas Club. (Courtesy of Dallas Heritage Village.)

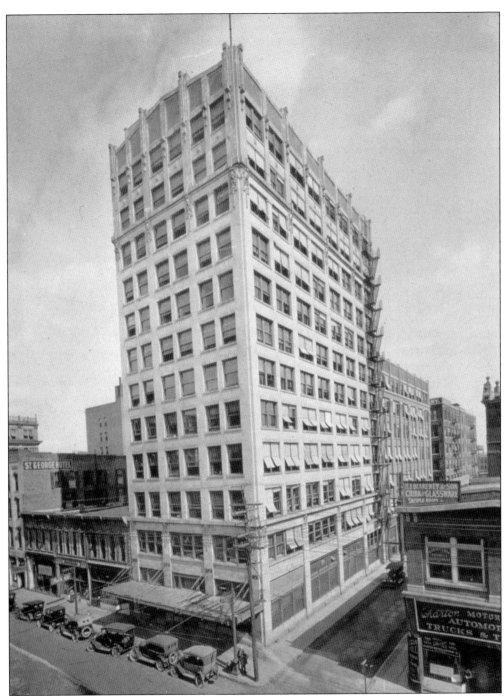

Commonwealth National Bank constructed at the corner of Main and Poydras Streets an impressive 12-story building to serve as its principal banking location. Finished in 1912, the first floor of the New Commonwealth Building featured a lobby with white marble and a stairway leading to a mezzanine level. More familiarly known as the Fidelity Building after the Fidelity Union Insurance Company purchased the building in 1925, the skyscraper served until 1969, when it was demolished for speculative office construction that was never realized.

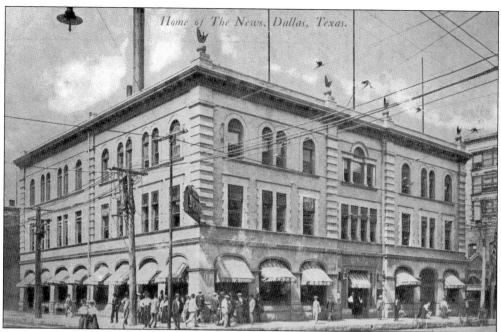

The *Dallas Morning News*, founded in 1885, erected this building that filled the corner of Commerce and Lamar Streets. The three-story brick building, designed by Herbert M. Greene, opened in 1900. Additions to this structure by the *Morning News* gave the daily the entire Commerce Street block face between Austin and Lamar Streets by 1913. The paper operated at this location for almost five decades, then moved to a new headquarters in 1949, and this portion of the block was taken down for a parking garage and drive-through bank for the neighboring Texas Bank and Trust Company. (Courtesy of Mark Rice.)

The handsome building at 911 Commerce Street was built in 1889 and served as offices for Friedman Hat Company through the 1960s. A four-story structure with a heavy Romanesque stone facade, distinctive bull's-eye window with keystone accent, and additional decorative pieces was demolished with the rest of the block for new speculative office construction. (Courtesy of the *Dallas Morning News*.)

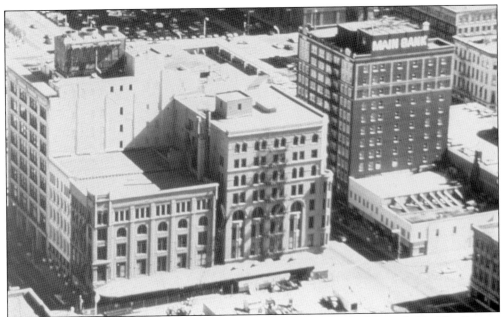

By the 1920s, Sanger's Department Store encompassed the entire block bounded by Elm, Lamar, Main, and Austin Streets. Founded by brothers Alex, Philip, and Lehman Sanger, the commercial enterprise became the largest retail business in the state and continued to innovate the local department store industry for decades at this location. After Sanger's was sold to Federated Department Stores in 1951, the complex was purchased in 1966 by the Dallas County Community College District to be used as its downtown campus, known as El Centro. Despite pleas by local preservationists to use the existing buildings, the majority of the block, save for the 1910 Lang & Witchell–designed, Chicago School–style portion facing Lamar Street, was lost in 1977.

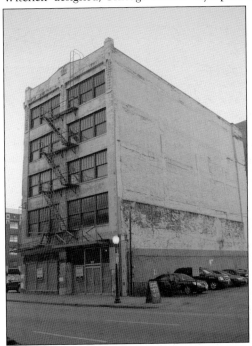

Constructed in 1925 for the C.A. Bryant Company, a wholesale school supply company, 807 Elm Street became a part of the larger Awalt Brothers furniture and warehouse complex beginning in 1939. The five-story structure, with large windows, Sullivanesque detailing below the cornice, and a crown motif centered in the parapet was deemed an imminent threat to public health and safety by the Landmark Commission and was taken apart on March 12, 2011.

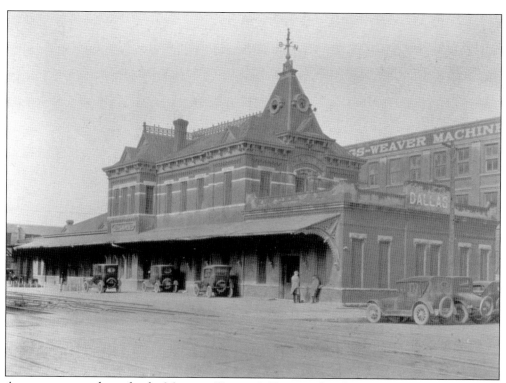

A new passenger depot for the Missouri, Kansas & Texas Railroad, also known as the MK&T or the Katy, was completed at the northwest corner of Market and Pacific Streets in 1892. The Second Empire–style structure with a modified mansard roof and a central tower topped with a metal weather vane lasted at this location until 1924, when it was erased for warehouse construction.

Dallas Fire Department Station No. 18 was located at the 1003 McKinney Avenue, near the intersection with Lamar Street. Serving the West End and North End neighborhoods, the two-and-a-half-story building lasted until the late 1970s, when it was replaced with a newer station. (Courtesy of the *Dallas Morning News*.)

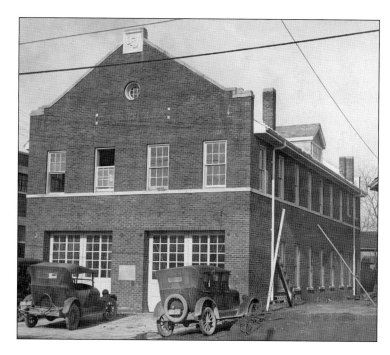

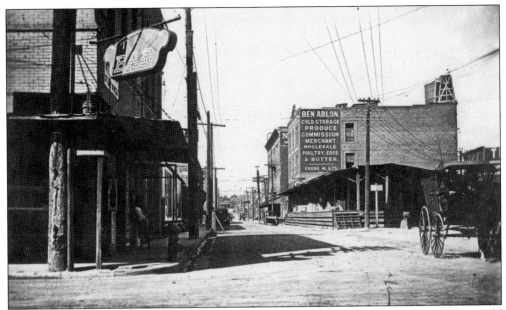

The T&P Bar, located at the corner of Camp and North Lamar Streets, and Ben Ablon Cold Storage further up Camp Street were just two of the businesses in this June 1917 image. Looking east up Camp Street, this area continued to regenerate and expand as the West End became the largest farm-implement market in the country. Camp Street was later renamed San Jacinto Street after the famous battle for Texas Independence. (Courtesy of the *Dallas Morning News*.)

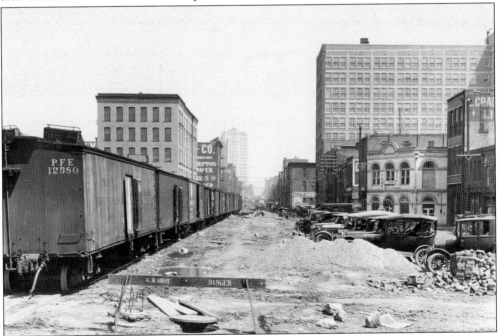

This April 1923 image of the corner of Pacific and North Lamar Streets shows that the removal of train tracks, as recommended by George Kessler's 1911 city plan for Dallas, had begun in earnest. Kessler advocated the removal of the railroad tracks in order to alleviate congestion and encourage develop on the north side of downtown. (Courtesy of the *Dallas Morning News*.)

This two-story masonry structure, located at 909 Elm Street, is important if only to serve as an example of the hundreds, if not thousands, of cast-iron commercial structures that lined downtown Dallas streets beginning in the late 1890s. Known as Ott's Lock Building, it was demolished in 1986.

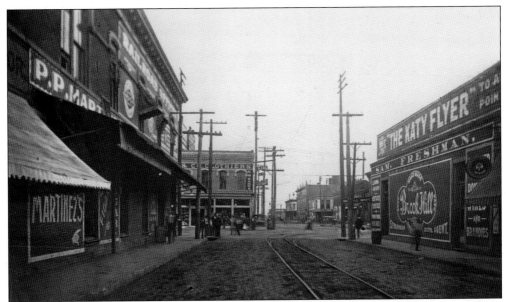

In February 1872, Emanuel Mayer Kahn established the first true clothing store in Dallas. Moving to a new location at the corner of Elm and Lamar Street in 1874, E.M. Kahn & Company continued to grow and prosper at the same spot until 1969, when the entire block was bulldozed for a planned extension of One Main Place. This image from 1895 shows Kahn's store at the intersection of Elm and Lamar Streets along with another building advertising the "Katy Flyer." (Courtesy of Temple Emanu-El.)

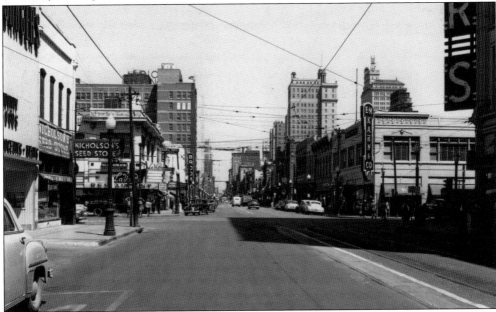

In the 1960s, Elm Street was still a bustling hub of retail and other commercial uses. E.M. Kahn & Company is visible on the right of the image, at the corner of Elm and Lamar Streets. The bottom of the famous Sanger's sign can be seen also on the upper right. Nicholson's Seed Store was on the north side of Elm Street. The Texas & Pacific Building, still standing but heavily modified, dominates the skyline toward the center of the photograph. (Courtesy of Temple Emanu-El.)

Two

CENTRAL BUSINESS DISTRICT

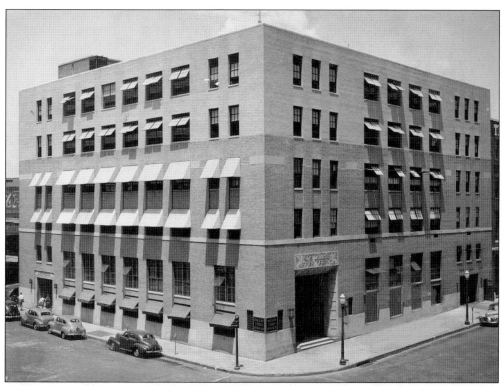

The 1929 headquarters of the *Dallas Times-Herald* was built to replace an earlier structure at 1305 Elm Street. The three-story building, designed by renowned firm Lang & Witchell, had a principal entrance that faced Pacific Avenue as well as first-floor business offices that included terrazzo floors, marble wainscoting, and ornamental plaster ceilings. Despite achieving parity with rival *Dallas Morning News* by the 1970s, mismanagement and declining circulation led to the paper's purchase by the Belo Corporation, parent company of the *Morning News*. On December 9, 1991, the final edition of the *Times-Herald* was printed, and the complex at Pacific and Griffin Streets was demolished thereafter. (Courtesy of the *Dallas Morning News*.)

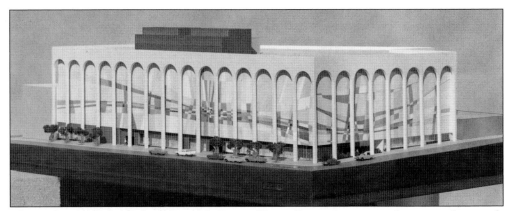

This scale model shows the mammoth Sanger Harris Department store that opened to much fanfare in 1965. A combination of the Sanger Brothers location on Lamar and Elm Street and the A. Harris & Co. location in the Kirby Building on Main Street, the 450,000-square-foot store at Akard and Pacific Streets was designed by Thomas Stanley. Also the headquarters for the entire Sanger Harris operation, the exterior of the building featured a trademark arched arcade and a colorful 55,000-square-foot mosaic by the Cavallini Company of New York. After the store closed in 1990, Dallas Area Rapid Transit (DART) purchased the building for its headquarters. Unfortunately, as part of the retrofitting of the structure, the sumptuous mosaic was covered over by white stucco and windows were punched into the facade. The Sanger Harris logo is still visible etched in a marble column at the corner of Akard and Pacific Streets. (Courtesy of the Texas/Dallas History and Archives Division, Dallas Public Library.)

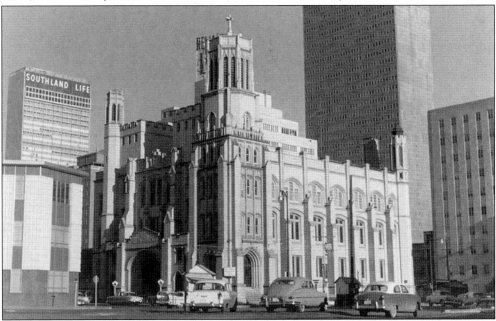

A growing Central Presbyterian Church commissioned architect C.D. Hill to design a new temple for its new home. City Temple, opened in 1917, was an elegant hybrid of Art Deco and Gothic architecture; it housed a horseshoe-shaped sanctuary and a rooftop garden. The structure, with its massive bell tower, perched on the corner of Patterson and North Akard Streets until 1963, after a diminished congregation sold the site to a parking lot operator. (Courtesy of the *Dallas Morning News*.)

The third YMCA facility in Dallas, this building at North Ervay and Patterson Streets was completed in 1931. Architect Anton Korn, in a departure from his residential designs, created a light-colored brick Art Deco landmark that featured a square central tower with a pyramidal roof. Among the many innovations the 14-story building included was a swimming pool on the well-ventilated third floor of the new structure as well as a rooftop track and 260 dormitory facilities. Replaced in the 1980s by yet another YMCA facility down the street, this structure was taken down in the early 1980s for the Lincoln Tower office complex. (Courtesy of Dallas Heritage Village.)

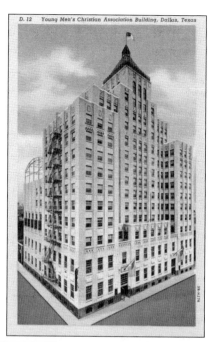

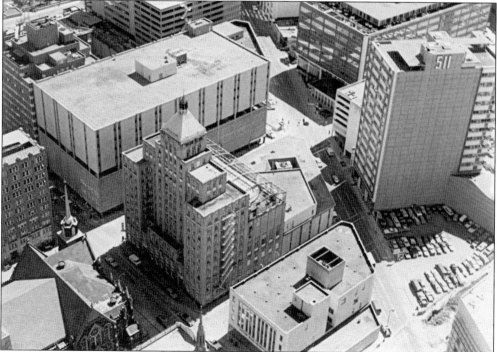

The rooftop track is visible on the west side of the YMCA facility in this aerial taken in the late 1970s. The YMCA building was a commanding presence and filled up the block facing North Ervay between Patterson and San Jacinto Streets. The entire block, along with the block immediately north of the YMCA, would be leveled and combined to accommodate the Lincoln Tower office building in 1984. The 1891 sanctuary of First Baptist Church, with its plain 1968 bell tower, is visible across North Ervay Street from the YMCA's front entry.

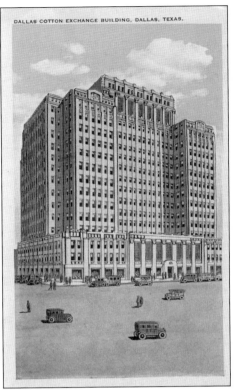

DALLAS COTTON EXCHANGE BUILDING, DALLAS, TEXAS.

Designed by renowned Dallas architecture firm of Lang & Witchell, the 17-story Dallas Cotton Exchange was built in 1925 at the height of Dallas being the world's largest inland cotton market. The cream-colored brick building trimmed with terra-cotta ornamentation contained 220,000 square feet of space and provided offices for both local and international cotton brokers. (Courtesy of Dallas Heritage Village.)

The Dallas Cotton Exchange began to decline by the early 1950s as synthetic fabrics and foreign competition began to cut into the market. Precast concrete panels were applied to the exterior of the building in a 1960s modernization attempt, and the building became completely vacant by the early 1990s. After several attempts at revitalization failed, the Dallas Cotton Exchange was imploded on June 25, 1994.

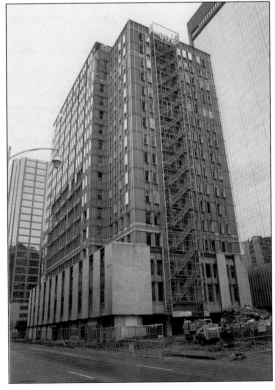

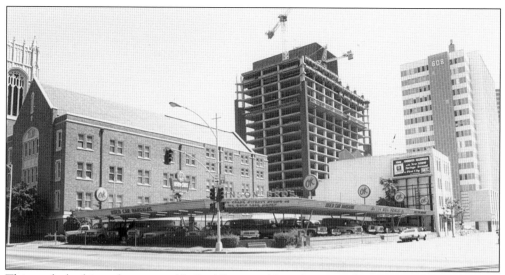

This car dealership at the corner of St. Paul Street and Ross Avenue indicates the type of commercial development that eroded what was originally one of the best residential thoroughfares in Dallas. Immediately next door is the main sanctuary for First United Methodist Church, which would later fill the entire block. The hulking mass of the Cotton Exchange Building, already clad in its 1960s slip facade, is visible in the right background.

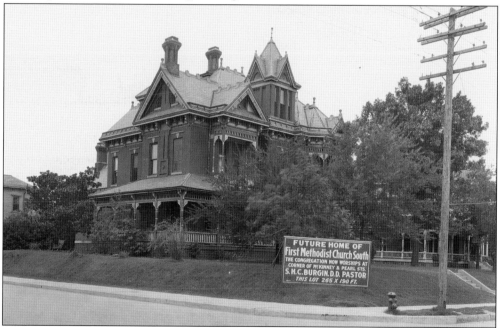

As the sign indicates, this location at the southwest corner of Ross Avenue and Harwood Street was slated for the new sanctuary of First Methodist Church South. Standing on the site was a rambling Victorian brick mansion occupied by Miranda Morrill. Completed in 1886 and designed by architect A.B. Bristol, the residence would come down in 1920. The Herbert M. Greene and R.H. Hunt collaboration for the congregation now known as First United Methodist Church was completed in February 1926 and still stands on the corner today. (Courtesy of the *Dallas Morning News.*)

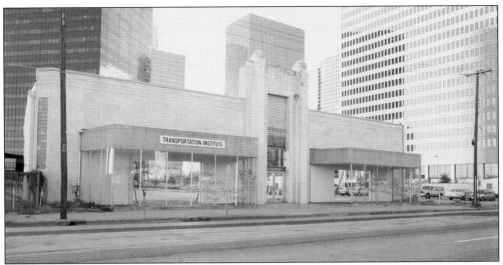

The Transportation Institute, located at 2222 Ross Avenue, near the corner of Pearl Street, was a one-and-a-half-story building with a distinctive Art Moderne glass block entry. The interior, lighted with huge plate glass windows, included two murals that depicted stages of automobile production. Despite efforts by the developer and city to disassemble and relocate the limestone facade, demolition was approved in 1984 for the new 55-story Chase Bank tower.

The home of Dallas business and civic leader George L. Allen sat at the northeast corner of Ross Avenue and Routh Street. Once located in the heart of Freedman's Town, an African American residential and commercial district, the two-and-a-half-story, modified Victorian brick structure was later used as offices for the Liberty Life Insurance Company as well as a trade school. Though completely restored in the early 1980s, the last remaining vestige of residential construction in the immediate area was demolished in 2006 for the construction of the new city performance hall.

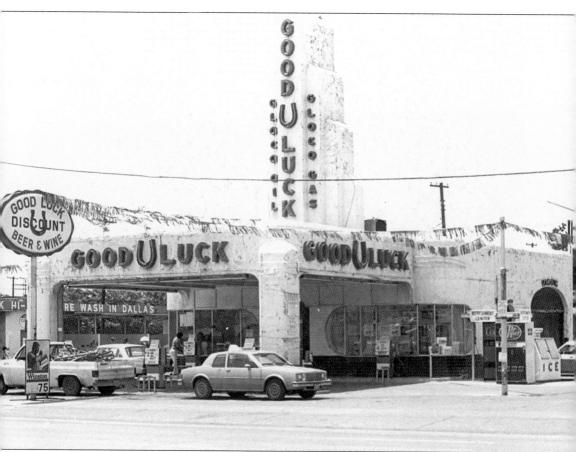

Constructed in 1939 to serve as a showcase for a fledging oil company, the Good Luck Gas Station was an Art Deco icon located at 2631 Ross Avenue. The 18,000-square-foot stucco station had a garish neon curved tower feature that served as a beacon for motorists entering downtown from East Dallas. Considered an exceptional downtown treasure, the location was cleared on December 22, 1982, despite economic incentives offered to the landowners. (Courtesy of Preservation Dallas.)

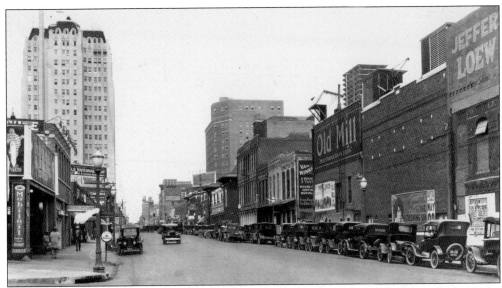

This early-1930s view looking east on Pacific Street at the Akard Street intersection shows the rear facades of the Old Mill and Loews Jefferson Theaters. Originally designed as a conduit for all the railroad traffic through downtown Dallas, train tracks were removed from Pacific by the early 1920s, and a concerted effort was made to create new entrances of buildings with Elm Street addresses that faced the wide avenue. The Medical Arts Building, on the left, and the Dallas Athletic Club, on the right, loomed over the area. (Courtesy of the *Dallas Morning News*.)

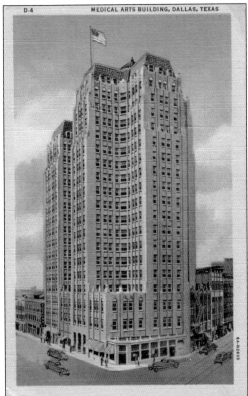

Architects Barglebaugh and Wilson's Medical Arts Building was a 21-story cream-colored brick wonder when it opened in 1923. Topped by a mansard roof, the cross-shaped building was the tallest reinforced concrete structure erected in Texas and was a commanding presence at Pacific Avenue and North St. Paul Street. The interior included a soaring atrium and elaborate murals depicting the medical field. The familiar landmark survived until 1979, when it was taken down for an expansion of the neighboring Republic Center. (Courtesy of Dallas Heritage Village.)

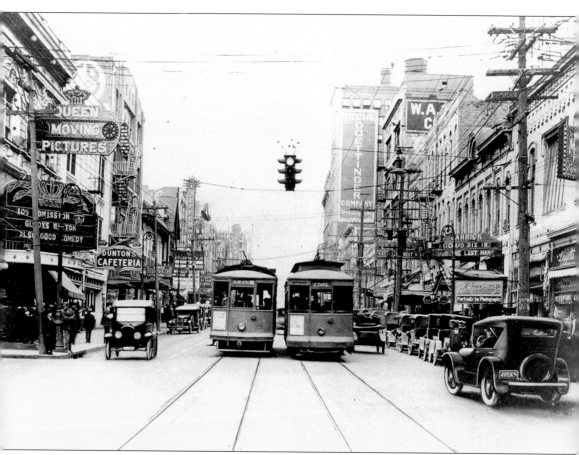

This famous view of Elm Street at Akard, taken in the 1930s, captures the vibrancy of what was known as Theater Row. Brightly lit theater, retail, and restaurant signage, passing streetcars, and a new automatic traffic light at the intersection all added to the hustle and bustle. Elm Street would remain the heart of Dallas's theater district until the 1960s, when all but one, the Majestic, closed.

Brewery wagons piled high with kegs of beer sit in front of Mayer's Summer Garden in this 1885 image. Located at Elm and Stone Streets, this popular watering hole also featured a small zoo and the city's first outdoor electric lights. (Courtesy of the *Dallas Morning News*.)

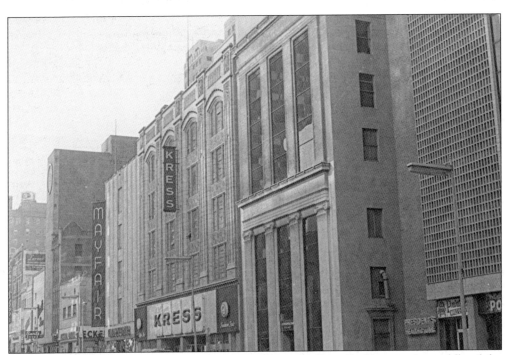

This 1970s view of the south side of Elm Street shows the Kress Building in the middle of the block and the Mayfair Department Store at the corner with Akard Street. The Kress Building, along with the six-story 1929 addition to the American Exchange National Bank building, would be gone by 1981.

The Kress Building, with its intricate terra-cotta facade, was built in 1901 for the Dallas location of the popular S.H. Kress & Co. five-and-dime chain. Envisioned by founder Samuel H. Kress as works of art to contribute to a city's streetscape, the Dallas Kress certainly fulfilled that desire. The massive six-story Art Deco structure included large arched windows and strong vertical pilasters topped with polychromatic terra-cotta detailing. The retail store at 1404 Elm Street closed in April 1980.

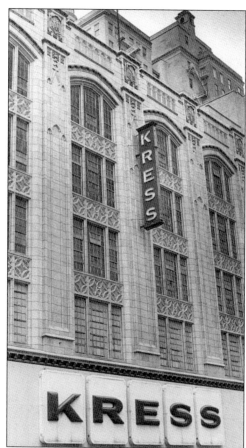

In the middle of an evening April thunderstorm, the new owners of the Kress Building began to demolish the facade. The following morning, a huge gaping hole had been created in the building. Although not locally protected, the late night defacing angered local preservationists and civic leaders. Despite those howls of outrage, the rest of the building, along with the neighboring American Exchange National Bank, was taken down in May 1981, leaving a parking lot in the middle of the block.

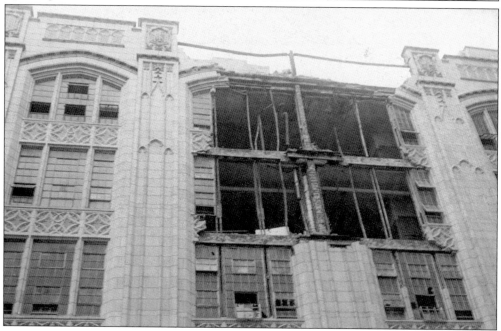

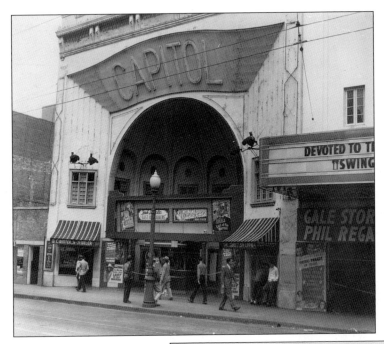

Although not as elaborate as neighboring theaters, the Capitol had a curved, recessed multistory facade that featured a bright neon "Capitol" sign and accent lighting. The theater, seating 1,200 and including a fountain in the lobby, closed in 1959 and was replaced by a parking lot. (Courtesy of the *Dallas Morning News*.)

Located next to the Capitol Theater, the Rialto was originally constructed in 1913 as the Old Mill Theater. Dallas firm LaRoche and Dahl placed an Art Deco facade on the building, and the interior was redesigned by Nena Claiborne in 1935. The Rialto's address at 1525 Elm Street meant it was in the middle of Dallas's fantastic Theater Row, where its flashing neon sign and marquee would herald many movie premieres. Though already slated for demolition, the Rialto burned in 1959. The LTV Tower stands on the site today. (Courtesy of the *Dallas Morning News*.)

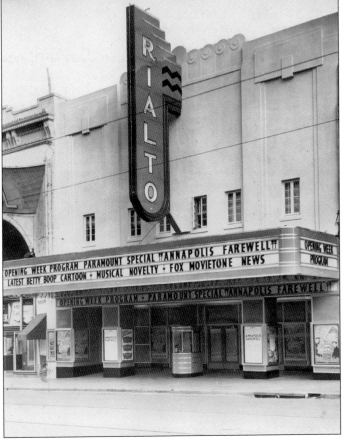

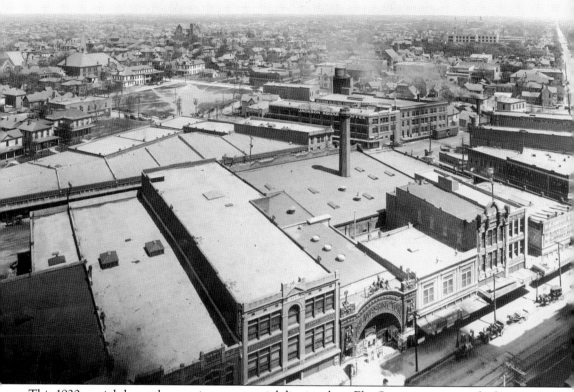

This 1920s aerial shows the growing commercial district along Elm Street, running in the lower right of the photograph, and the surrounding residential neighborhoods looking to the northeast. The Washington Theater is visible in center lower right, signaling the beginning of Elm Street as the entertainment epicenter of Dallas. (Courtesy of the *Dallas Morning News*.)

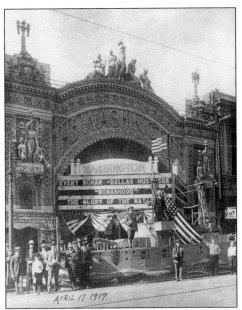

Opening on Thanksgiving Day, 1912, the Washington Theater was one of the first combination vaudeville and silent motion picture palaces in Dallas. The gaudy exterior of the Washington, with marble-faced ticket booth and bronze statuary across the arched parapet, was lit brightly at night. Although it successfully made the transition to talkies, newer and larger theaters, as well as harsh economic conditions, eclipsed the Washington, and it was leveled in 1932. (Courtesy of the *Dallas Morning News*.)

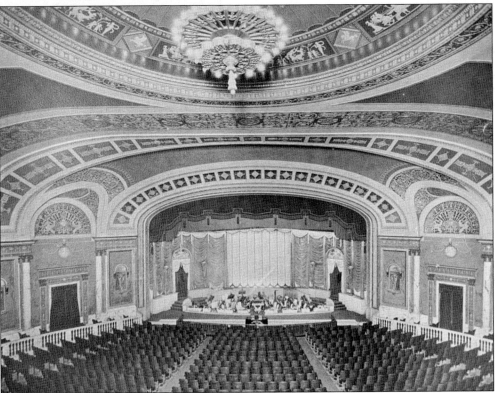

Marble columns, a magnificent Wurlitzer organ, and an exquisite domed ceiling with a sparkling chandelier in the center greeted patrons when the elegant Palace Theater opened in 1921. The work of architect C.D. Hill, the Palace was located at 1625 Elm Street, near the intersection with Stone Street. A local favorite until it closed in 1970, the 2,435-seat theater was cleared for Thanksgiving Tower. (Courtesy of the *Dallas Morning News*.)

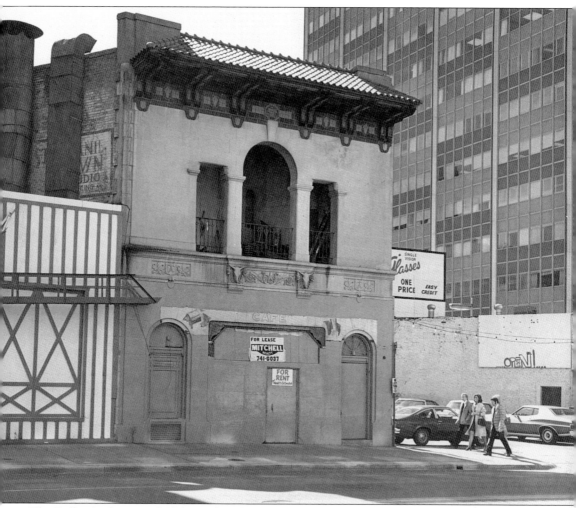

The Dallas Architectural Club was founded in 1920 and met at several downtown hotels until an existing building could be found to serve as a clubhouse. When the train tracks were removed from Pacific Avenue as part of George Kessler's 1911 plan, the members had a new facade constructed on that side of the building located at 1711 Live Oak Street, chosen in 1924. The purpose and hope of the new entry was to lend an air of "City Beautiful" elegance and serve as a model of future architectural development along Pacific Avenue. The modified Spanish Renaissance–style facade hinted at what the building housed: a first-floor assembly hall and theater (the Rex), a second-floor club, and a rooftop workshop and studio. When the Great Depression spread across the country, the Dallas Architectural Club folded, and the building served as several other uses, including a Mexican food restaurant until 1981, when the entire block and Live Oak Street grid was obliterated for a new downtown skyscraper.

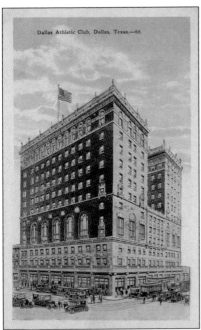

Dallas Athletic Club, Dallas, Texas.—66

Another Lang & Witchell design was the Dallas Athletic Club (DAC), finished in 1925. The spectacular Sullivanesque-style building included retail, office, and residential space along with facilities for club members to swim, box, dance, and dine. Located at the corner of Elm and North St. Paul Street, the DAC was abandoned when new facilities were completed in 1953. DAC sold the property in 1977 for office space, and the 13-story Georgian structure was taken down in 1981 for new skyscraper construction. (Courtesy Dallas Heritage Village.)

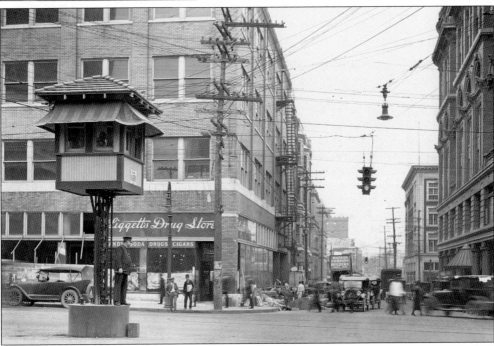

The tower on the left, erected in May 1923, housed remote controlled switches that operated all traffic signals downtown, one of the many attempts to control traffic flow in Dallas's increasingly congested central business district. Located at the intersection of Elm, Live Oak, and Ervay Streets, the tower would be removed in the 1940s. Also visible in this 1929 view are Liggett's Drug Store and the Ervay Street facade of the Middleton Brothers, then called the Lansing Building. The east facade of the Wilson Building, still standing, fills the right side of the image. (Courtesy of the *Dallas Morning News*.)

42

A gaping hole in the majestic front facade of the Volk Brothers building is visible in this September 1980 image. A masterpiece of Greene, LaRoche, and Dahl, Volk Brothers was finished in 1930 to house the headquarters of the longtime Dallas establishment. The French Renaissance structure, with its limestone facade, green copper roof with dormer windows, and Art Deco canopy of cast iron and glass, functioned as retail space until 1973. Despite being listed on the National Register months before, a skittish developer pulled a demolition permit and began demolition on a Saturday night. The structure was completely removed by the end of September, and the block today is filled with the Comerica Bank Tower. (Courtesy of the *Dallas Morning News*.)

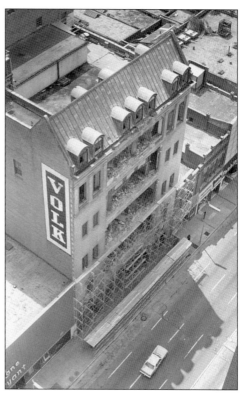

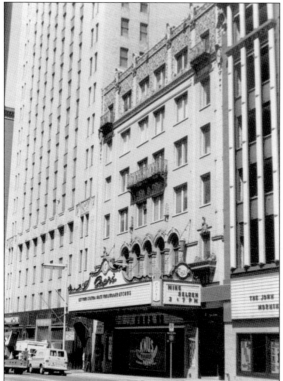

The popular Melba Theater, addressed as 1913 Elm Street, was completed in 1922. The six-story building, which extended from Elm to Pacific Street, included a 2,000-seat auditorium with mezzanine and balcony. Office space was located on floors above. Remodeled and renamed the Capri in 1959, the theater operated until 1971, when it was lost for a new office tower.

43

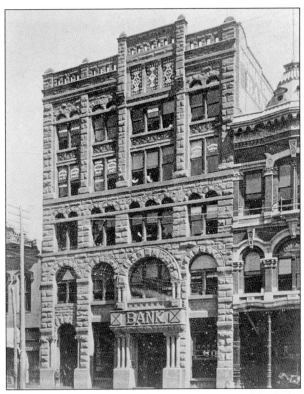

This 1894 image shows the National Exchange Bank, located at Main and Poydras Streets. The fortress-like Richardsonian Romanesque sandstone facade expressed stability, which was imperative for banking customers during the 1880s and 1890s. Expanded several times over the ensuing decades, the building saw various uses after the bank moved to larger accommodations up Main Street. It was taken down in 1940. (Courtesy of the *Dallas Morning News*.)

A collaboration of architects James Reily Gordon and H.A. Overbeck, the Linz Brothers Building was constructed in 1898. A transition between Richardsonian Romanesque and the more fashionable Chicago School of design, the six-story buff brick–and–gray granite edifice was also considered the first fireproof building in Texas. The interior was famous for its polished marble, paneled ceiling, and horseshoe-shaped display counters. Although a seventh floor was added to the building, Linz Brothers sold the structure to the Rio Grande Bank in 1939. After Rio Grande Bank sold the building in 1947, the remodeled structure, located at the corner of Main and Martin Streets, survived until it was torn down in 1962.

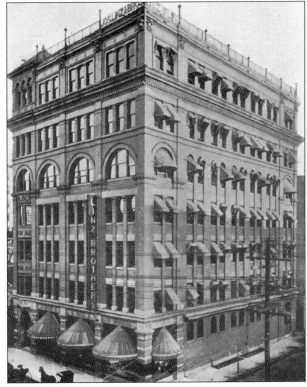

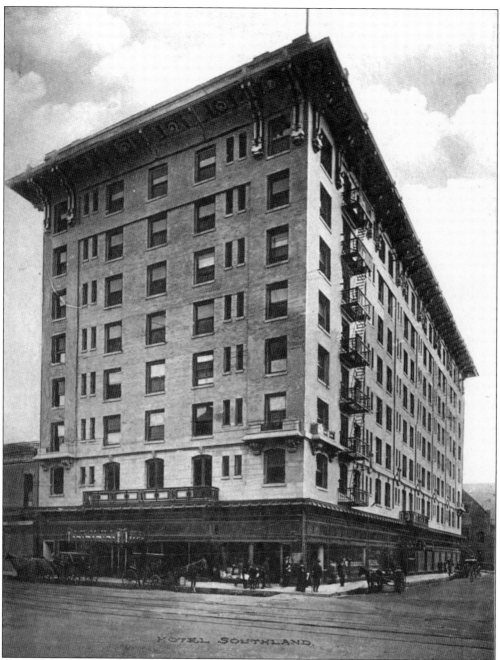

HOTEL SOUTHLAND.

John Parkinson designed the Southland Hotel at Main and Murphy Streets in 1907. It was the first building in the city to use steel-framed construction and was considered fireproof by owner J.W. Hunt. It had a drinking fountain that dispensed cold water through a figure of Venus and was the nation's second hotel with running ice water in every room. The building also featured many technological innovations, such as mail chutes on every floor and a vacuum cleaning apparatus. It also featured a mahogany paneled bar, restaurant, drugstore, and ladies' parlor. Spanning the entire east side of the block between Main and Commerce Streets along Murphy, the Southland was demolished in 1971 for office construction.

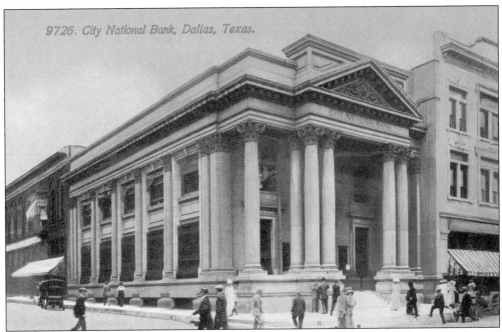

Located at 1201 Main Street, near the intersection with Murphy Street, the City National Bank building was considered a neoclassical masterpiece when completed in 1903. The Fort Worth firm of Sanguinet & Staats designed a monumental temple front with eight Corinthian columns. The interior had a barrel-vaulted main lobby space and a marble staircase that led to second-floor office space. Expanded with a new Beaux-Arts facade in 1917, the elegant building occupied the site until the entire block was cleared in the 1964 for new office tower construction. (Courtesy of Mark Rice.)

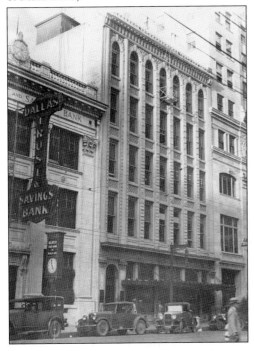

Dallas Trust and Savings Bank, located at the extreme left of this image take in April 1930, though organized in 1903, did not move into this structure until 1917. Architects Hubbell & Greene designed a three-story institution with a polychromatic terra-cotta facade, Corinthian pilasters, and cornice with balustrade. The bank was taken over completely by Dallas Title & Guaranty in the early 1930s, and that business remained in the building at 1301 Main Street until 1964, when it was demolished for modern office construction. (Courtesy of the *Dallas Morning News*.)

Capt. J.B. McLeod opened the 143-room McLeod Hotel on Main Street in April 1890. One of Dallas's first tall buildings, the seven-story building was considered a skyscraper. It was sold, refurbished, and renamed in 1904 as the Imperial Hotel. The hotel was severely damaged by fire in 1914, and the American Exchange National Bank purchased and cleared the block in 1916 for its new headquarters. (Courtesy of the *Dallas Morning News*.)

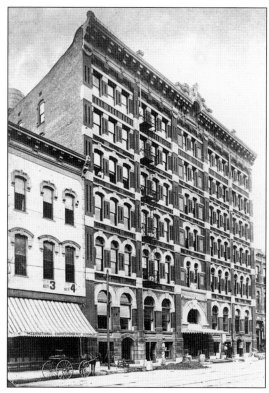

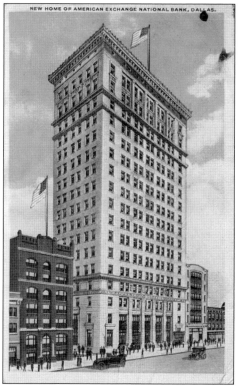

Rapid growth of the Dallas business and banking communities necessitated American Exchange National Bank to build a new headquarters at 1401 Main Street. Completed in September 1918, the Lang & Witchell–designed 16-story skyscraper (with basement) featured a granite-and-limestone facade topped with an elaborate terra-cotta cornice. Remodeled and expanded to include a motor bank on Elm Street, the massive structure served various banking institutions until it was demolished in 1981 for a parking lot. (Courtesy of Dallas Heritage Village.)

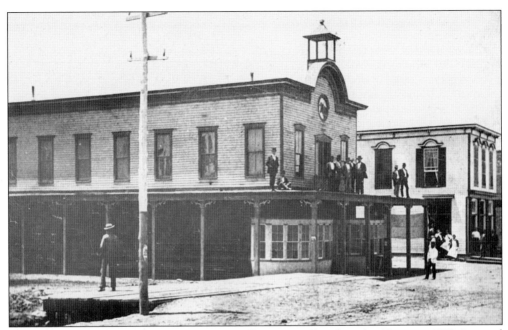

Mayor Ben Long supervised construction of Dallas City Hall and Market House in 1872. Located at the southwest corner of Main and Akard Streets, city offices were located over a ground-level farmers market that sold fresh vegetables, meat, fish, and poultry. This wood structure, with an arched parapet and small tower, lasted a scant eight years until it was taken down in 1880; a more substantial masonry building was constructed at Commerce and Lamar Streets. (Courtesy of the *Dallas Morning News*.)

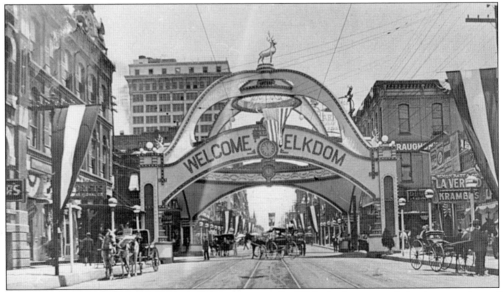

Erected in 1908 for the Elks National Convention, the Elk's Arch spanned the intersection of Main and Akard Streets. The arch, with working clocks and a majestic elk statue perched on top, became an instant landmark and remained in place until 1910, when it was quietly dismantled after becoming associated with the lynching of Allen Brooks, the last to occur in Dallas County. (Courtesy of the *Dallas Morning News*.)

Architects Lang & Witchell designed the Southwestern Life Building at the southeast corner of Main and Akard Streets. Completed in 1913, the Sullivanesque design dramatically expressed the verticality of the 16-story structure, with an articulated base, brick shaft, and an overhanging cornice with intricately detailed terra-cotta moldings. Southwestern Life occupied the building until moving to new offices in 1964, and the familiar skyscraper was taken down in 1972 for a parking lot. (Courtesy of Dallas Heritage Village.)

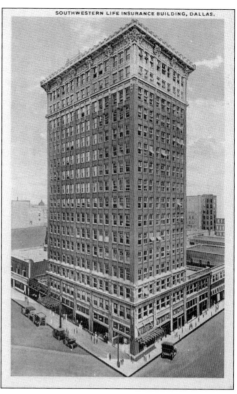

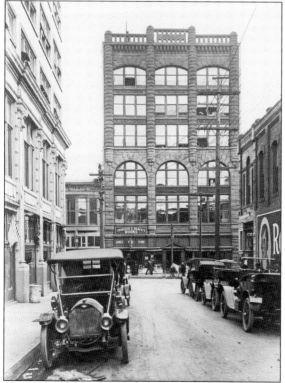

Located where Stone Street dead-ends at 1530 Main Street, the six-story Jennie Building was built in 1891. The Chicago School–style building, with its heavy stone facade and large windows, became known as the Deere Building after it was purchased by the John Deere family in 1917. The building was demolished for the C.D. Hill, Coburn, Smith and Evans–designed headquarters for the Dallas National Bank, which opened in 1927. (Courtesy of the *Dallas Morning News*.)

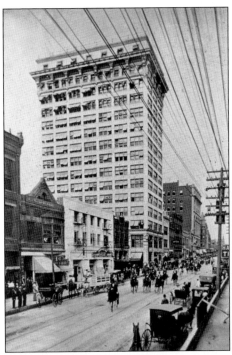

The Praetorian Building was opened in July 1909 as the first steel skyscraper in Dallas. Designed by Clarence Bulger & Son and standing at 14 stories tall, the Praetorian featured a facade clad in light-colored brick and terra-cotta detailing topped with a 15-foot cornice. When the building, located at the corner of Main and Stone Streets, was enlarged and completely remodeled in 1959, the elaborate exterior facade was destroyed. The Praetorians, a fraternal insurance society, vacated the building in 1987. The building was demolished in 2012.

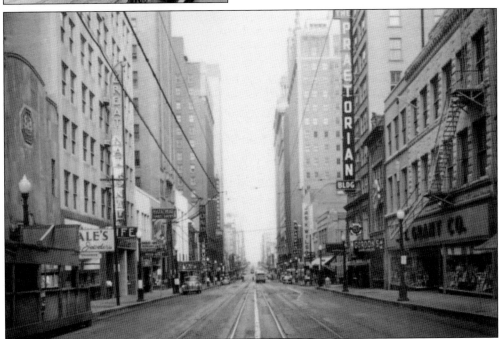

Zale's Jewelers, Southwestern Life, A. Harris & Co., and Jas. K. Wilson are just a few of the signs visible in this 1960s view of Main Street looking west. With the rise of suburban shopping centers and residents starting to migrate to new housing developments further out from the central business district, downtown as a retail and office destination began its slow but steady decline during this period. By the early 1990s, most of these familiar establishments had closed. (Courtesy of the *Dallas Morning News*.)

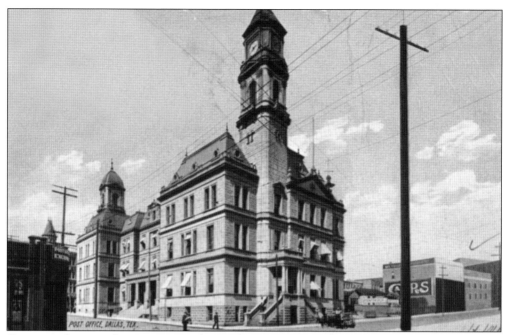

Constructed in stages between 1884 and 1904, the US Post Office Building eventually filled the entire east block face of Ervay Street between Commerce and Main Streets. Also home to the North Texas US Circuit District Court, the landmark building included two towers, one with a four-faced clock that was beloved for keeping accurate time. When the government sold the structure for $125 in 1939, the mantels, marble fireplaces, and chandeliers were also removed and sold. The site was cleared for the new Mercantile National Bank building in 1941. (Courtesy of Dallas Heritage Village.)

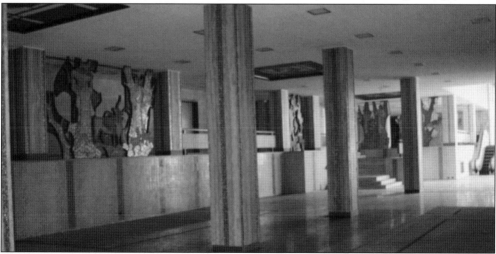

The Mercantile National Bank continued to expand and grow with additions that filled the entire city block bound by Ervay, Main, St. Paul, and Commerce Streets. Well-known California designer Millard Sheets was commissioned to design interiors for the complex, including those for the 1958 Dallas Building. Gold-colored tile-inlaid columns, mosaic grilles in multilevel lobby areas, and intricate star and planet mosaics set in travertine walls all contributed to the sumptuous banking spaces. Many of the priceless works of art were rescued when the majority of the Mercantile complex was demolished in 2006 for new residential construction. (Courtesy of Marcel Quimby.)

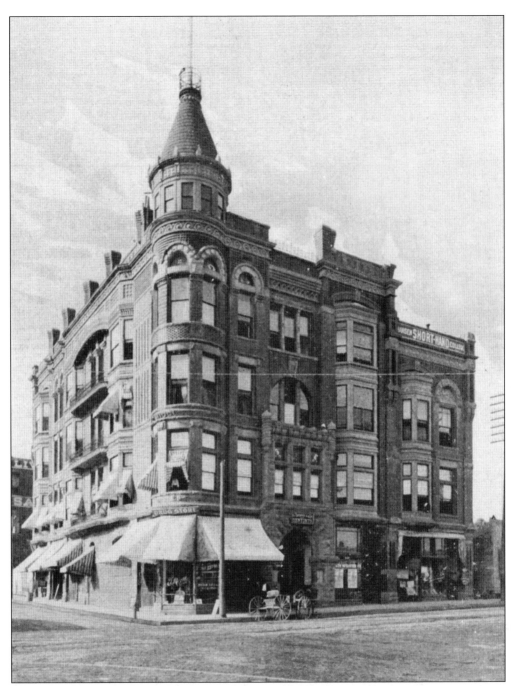

Constructed as office space for a growing real estate and grave marker business, the Middleton Brothers Building was finished in 1892, just in time for the financial panic of 1893. The four-story red-sandstone High Victorian structure with a gingerbread corner turret sat at the northeast corner of Main and Ervay Streets. Housing a Marvin's Drug store on the first floor, the building was remodeled and renamed the Lansing Building after a fire in 1922. Dreyfuss & Son Clothiers purchased the building and razed it in 1929 for a new retail establishment. (Courtesy of the *Dallas Morning News*.)

A large crowd is gathered outside the first Dreyfuss & Sons store located at the corner of Main and Murphy Streets. Quickly outgrowing this three-story building with its Victorian turret, the Dreyfuss family was bought out by Woolf Brothers of Kansas City, and plans were made to move further east up Main Street. (Temple Emanu-El.)

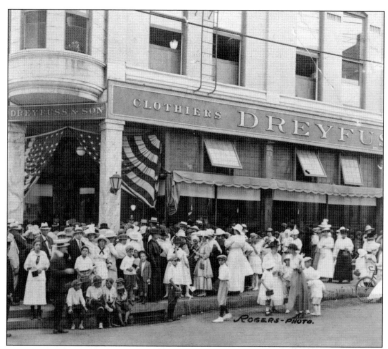

In 1930, Dreyfuss & Sons opened this six-story building, replacing the Lansing Building. Kansas City architect Alonzo H. Gentry created a modified classical-style building that had a native limestone–and–polished granite facade as well as window spandrel accents and carved pilasters. When Woolf Brothers consolidated all their stores under one name in 1973, the Dreyfuss & Sons label disappeared. This outstanding building would follow in 1985 for speculative retail construction.

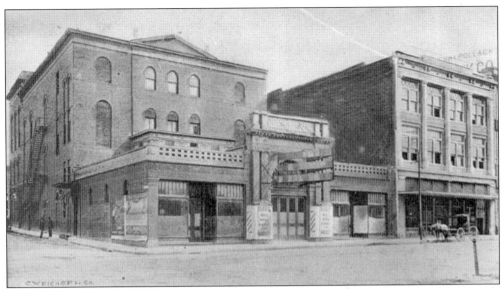

Replacing an earlier opera structure that burned in April 1901, the Dallas Opera Block was hastily completed by November 1901. Situated at the corner of Main and St. Paul Streets, the complex was designed by noted Fort Worth architecture firm Sanguinet & Staats. The building burned in 1921. (Courtesy of the *Dallas Morning News*.)

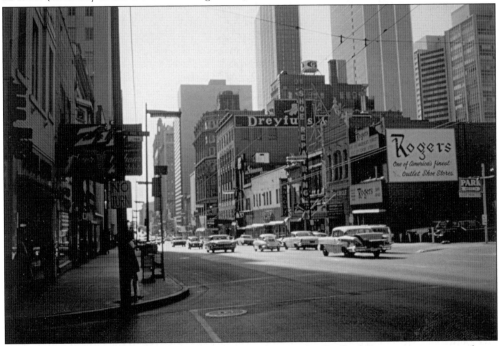

This view of the north block face of Main Street, close to the St. Paul Street intersection, shows several downtown retail fixtures, including Dreyfuss & Sons and Rogers Outlet Shoe Store. The signage on the far right indicates that parking lots had started to invade this block. The entire block would be taken down in 1985 for a proposed shopping center that was never built. The Philip Johnson and John Burgee–designed Comerica Tower, rising in 1987, was placed on the site. (Courtesy of Preservation Dallas.)

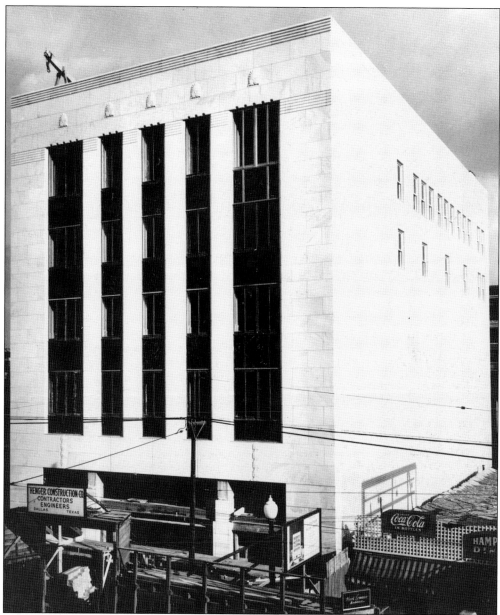

Located at 1910 Main Street and opened in 1937 as the largest bookstore in Dallas, the Cokesbury Bookstore sported a handsome Art Deco Georgian marble facade designed by Dallas architect Mark Lemmon. Influenced by the architectural style of the Texas Centennial Exposition in Fair Park, the Cokesbury Bookstore was expanded in 1949 with a three-story addition and storefront on Commerce Street. This made the Cokesbury the largest bookstore in the United States. Such notable literaries as F. Scott Fitzgerald, John Steinbeck, William Faulkner, and even Howard Cosell had book signings in the building. Business began to shrink in the 1960s, and the real estate boom of the early 1980s killed the store, which closed in 1983. The entire block was sold to a developer with designs for another downtown high-rise, which never materialized. The building managed to hang on until 1993, when the property owners, claiming economic hardship, were allowed demolition by the city council.

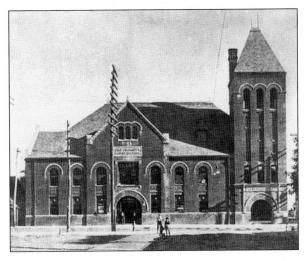

The Gulf, Colorado & Santa Fe Railroad and the St. Louis & Southwestern Railway (commonly called the Cotton Belt) replaced a wood depot with this Richardsonian Romanesque terminal in 1896. Sitting at the corner of Commerce and Murphy Streets, the building with its massive tower and curved entry elements served passengers until the new Union Station terminal was completed in 1916. In September 1923, construction began on the present 19-story Santa Fe Terminal No. 1. (Courtesy of the *Dallas Morning News*.)

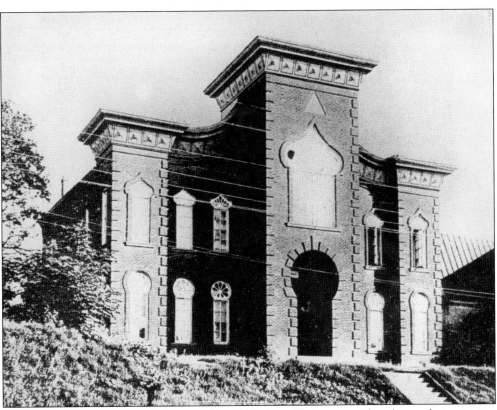

The first Jewish temple in North Texas, Temple Emanu-El, constructed at the southwest corner of Field and Commerce Streets, was finished in 1876. Credited to local architect James Flanders, the Temple had some notable features, such as the central pavilion accompanying by two smaller corner tower elements and Moorish Revival window openings. As the surrounding neighborhood turned more commercial, the temple moved to more spacious accommodations on South Ervay and St. Louis Streets in 1898. This structure served a short time as the University of Dallas Medical Department before demolition in 1906. (Courtesy of Temple Emanu-El.)

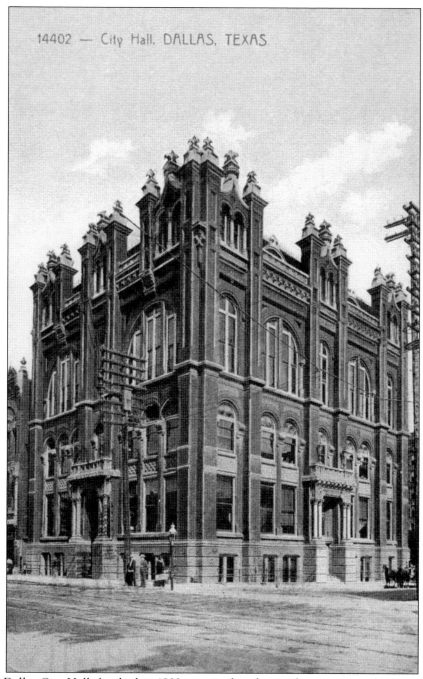

14402 — City Hall. DALLAS, TEXAS.

A new Dallas City Hall, finished in 1889, was sited at the northwest corner of Commerce and Akard Streets. Costing $80,000, the three-story building, including a basement, was constructed of red brick and buff sandstone with arched windows, entries flanked by pairs of columns, and elaborate potted-plant finials ringing the peaked roof. City leaders agreed to sell the land, coveted by beer baron Adolphus Busch, in May 1910, and with city offices relocated to temporary quarters, demolition began in October 1910. The present Adolphus Hotel opened in October 1912. (Courtesy of Mark Rice.)

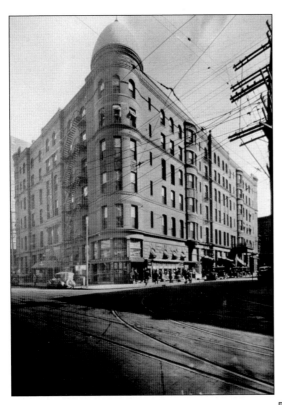

The Oriental Hotel was the considered the finest hotel in Dallas when it was finished in October 1892. Sitting at the corner of Akard and Commerce Streets, the ground floor contained a lobby complete with marble floors, an elegant dining room, an extensive newsstand, and a barroom with the first tile floor in the city. The six-story dark red brick structure with its distinctive onion-domed turret hosted presidents, governors, and other dignitaries until it was demolished in 1924 for the Baker Hotel.

Built by T.B. Baker for $5.5 million, the Baker Hotel officially opened on October 9, 1925, with a gala later that month that included a ceremonial throwing away of the keys to symbolize that the hotel would remain open day and night. Designed by St. Louis architect Preston J. Bradshaw, the Baker stood 18 stories tall and held 700 rooms. Peacock Terrace, modeled after an old English inn, was the place for a private party, wedding reception, elegant ball, or other special occasion. Although Southwestern Bell purchased the entire block along with the one across the street in July 1979, it was not announced until July 1980 that a "magnificent" three-building administrative complex would be constructed on the site. On August 31, 1979, the Baker shut its doors for good, and at 11:53 a.m. on Sunday, June 30, 1980, with a small poof of black smoke, the Baker was imploded. (Courtesy of Dallas Heritage Village.)

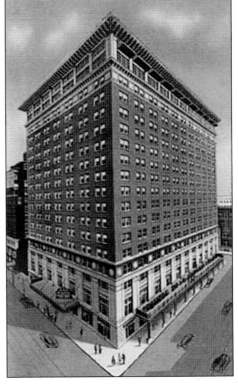

Another Lang & Witchell design, the 10-story Southland Life Building was considered one of Dallas's earliest skyscrapers. Finished in 1918, the headquarters for the Southland Life Insurance Company featured three passenger elevators, hot and cold running water in each office suite, and a rooftop garden. The Classical Revival brick building, located next to the Baker Hotel on Commerce Street, was taken down in 1980 with the rest of the block for the Southwestern Bell (now AT&T) complex. (Courtesy of Dallas Heritage Village.)

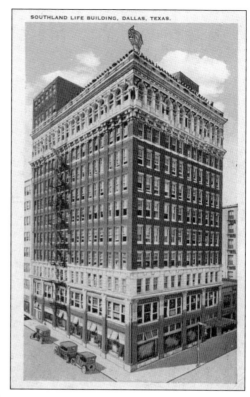

SOUTHLAND LIFE BUILDING, DALLAS, TEXAS.

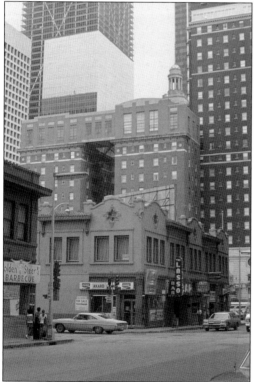

The block facing Akard between Commerce and Jackson Streets became a notorious location for supper and burlesque clubs. The Montmartre Club, the Colony Club, and the Carousel Club, owned by infamous Dallas resident Jack Ruby, were just a few of the establishments clustered close to the Adolphus and Baker Hotels. The entire block would be cleared for the Southwestern Bell (now AT&T) complex in 1980. The 1917 Lang & Witchell–designed 12-story addition to the Adolphus Hotel is visible in the background.

59

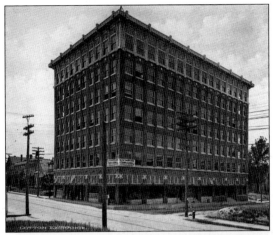

Dallas's transformation from a sleepy town to a major business center began soon after the seven-story Cotton Exchange Building opened in 1910. Located at the southwest corner of Akard and Wood Streets, this building was the epicenter of the Dallas business community until 1926, when the exchange moved to larger quarters further north. Converted to office space, this forgotten building received a new metal-and-brick facade in the 1950s before completely emptying out and being demolished in May 2006 for a parking lot.

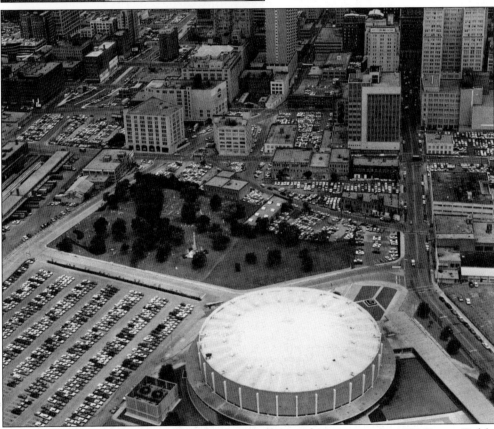

Pioneer Cemetery, the first planned cemetery in Dallas, is visible next to the 1957 George Dahl–designed civic arena and theater in this aerial view. The massive Santa Fe Freight Terminal and Warehouse complex, located in the middle of the image, is virtually intact except for Building No. 3, which was demolished in 1988 for a parking lot. All the other small commercial structures along Young and Marilla Streets would disappear in the 1970s to accommodate the new Dallas City Hall, to be constructed in the block on the far right of the photograph. The civic arena and theater, still present, would be added onto multiple times over the ensuing decades to create the current Dallas Convention Center.

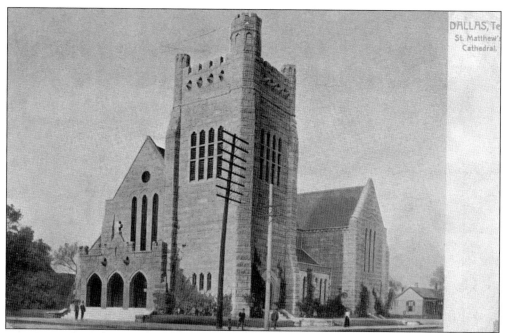

The third St. Matthew's Episcopal Cathedral was built by at the northeast corner of South Ervay and Canton Streets between 1894 and 1895. Designed by Fort Worth's Arthur Messer at a cost of over $100,000, St. Matthew's dominated the corner with its heavy, flat-topped stone tower and crenulated parapet. After the diocese built a new cathedral in East Dallas along Ross Avenue in 1929, the cruciform structure built of Comanche sandstone was demolished in 1937 to halt further deterioration. (Courtesy of Dallas Heritage Village.)

The massive Richardsonian Romanesque Butler Building, located at 500 South Ervay Street, was constructed by Butler Brothers of Chicago, a wholesaler and operator of variety stores in 1906. One of the largest structures in Dallas at the time, the eight-story building was expanded in 1917. Converted to the Dallas Merchandise Mart, a wholesale showroom center, in 1955, the arched windows, decorative red brickwork, and crenulated parapet were covered in beige concrete panels and layers of stucco in the 1960s. The building still stands in its modified condition.

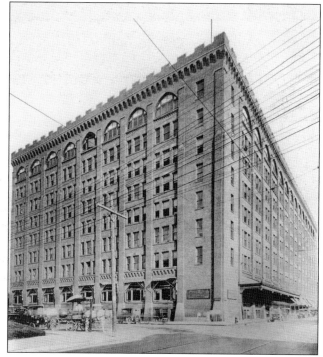

The Eli West Theater, located at 303 South Ervay Street, was housed in a three-story cast-iron commercial structure. The tall, narrow arched windows and corbelled brick cornice were characteristics of the 1910 building, and it was used as part of the Willard Hotel at one time. Surrounded by a sea of asphalt, the Eli West survived until the mid-1980s, when it was taken down for parking space. (Courtesy of Preservation Dallas.)

YMCA Dallas opened its first building, shown here in 1899, at Commerce and Jackson Streets. The three-story brick structure with projecting triangular-shaped parapet and brick finials served for a short time period before overcrowded conditions led to the construction of a new facility in 1909. (Courtesy of the *Dallas Morning News*.)

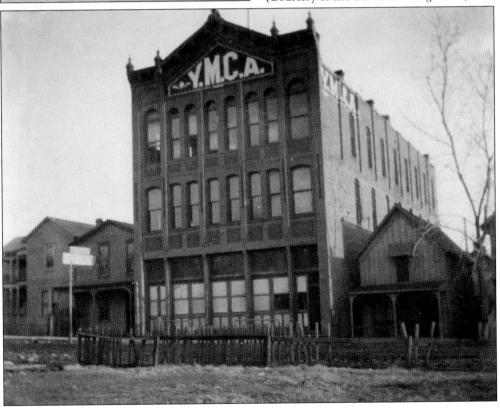

Oak Grove School was built in 1884 as one of the original four schools in the Dallas Public School system. Located on the southeast corner of South Harwood Street and Jackson Street, the original Oak Grove School was replaced by this new building, designed by architect A.B. Bristol, in 1889. Oak Grove School was identical in Victorian style to Cumberland Hill School, still extant, located on the north side of downtown. Valuable due to its close proximity to the bustling business district, the Oak Grove School was torn down in 1915 after the board of education received an offer of $108,000 for the property.

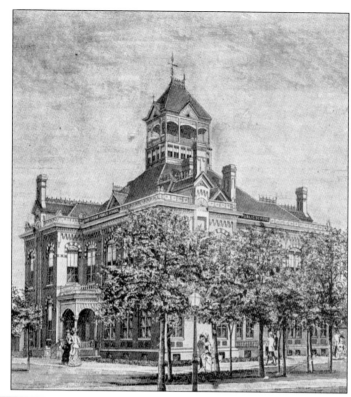

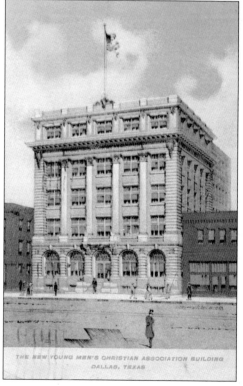

Replacing the first YMCA structure located on Jackson Street, Lang & Witchell designed this refined neoclassical structure in 1909. Addressed at 1910 Commerce Street, near the intersection with St. Paul Street, the five-story building contained a gymnasium, running track, and 54 dormitories. This facility would also soon be crowded, and the YMCA vacated for larger accommodations in 1931. The handsome structure served Dixie University School of Law as well as the Savoy Hotel before the location was cleared in 1950 for construction of the Dallas Statler Hilton Hotel. (Courtesy of Dallas Heritage Village.)

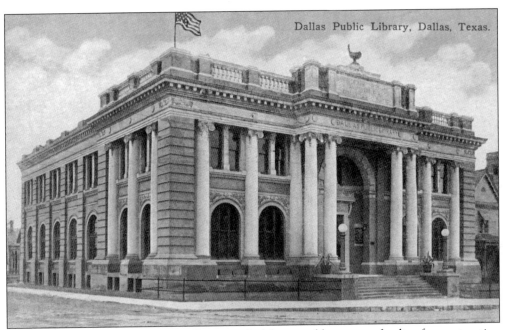

Dallas Public Library, Dallas, Texas.

With help from Andrew Carnegie, Dallas women's clubs were able to secure funding for construction of the first true library facility in Dallas. Thousands attended the opening-day festivities on October 29, 1901, to enter the neoclassical building designed by the Fort Worth firm of Sanguinet & Staats. Located at the southwest corner of Commerce and Harwood Streets, the Carnegie Library included a large circulation desk and a second-floor auditorium reached by an elegant set of stairs. A victim of its own success, the facility became woefully overcrowded, and after officially closing on December 15, 1953, the well-loved repository was completely cleared in 1954. (Courtesy of Mark Rice.)

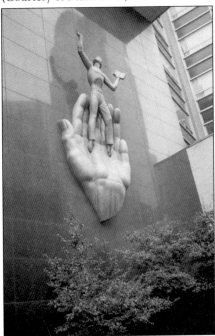

Although opened in September 1955, Marshall Fredericks's sculpture of a boy with a book in his hand reaching for the skies, titled *Youth in the Hands of God*, was not installed on the exterior of George Dahl's modern library masterpiece until August 1956. It was originally sketched to show the youth unclothed, but the shocked conservative library board voted to add pants, and Fredericks reluctantly agreed. When the building was vacated in 1982, the aluminum–and–magnesium alloy sculpture remained in place until the artist's family received approval to remove the sculpture in 1993 and return it to their collection.

A KlerKold Ice delivery truck is parked on Commerce Street in front of nondescript one- and three-story buildings located next to the Dallas City Hall. These buildings were removed to accommodate a new city hall annex designed as a collaboration between Mark Lemmon and Smith & Mills and finished in 1956. The basement parking tunnel of the new annex would be the site of the nationally televised shooting of Lee Harvey Oswald by Jack Ruby on November 24, 1963. (Courtesy of the *Dallas Morning News*.)

One of the oldest congregations in Dallas, Central Presbyterian Church occupied this handsome Victorian Gothic structure at the corner of Commerce and Harwood Streets. The two-story brick building with its distinctive entry towers and large stained glass windows served until 1917, when the burgeoning congregation outgrew the space and moved to its new address at Patterson and North Akard Streets. The edifice would be cleared by 1920 for new commercial construction. (Courtesy of Mark Rice.)

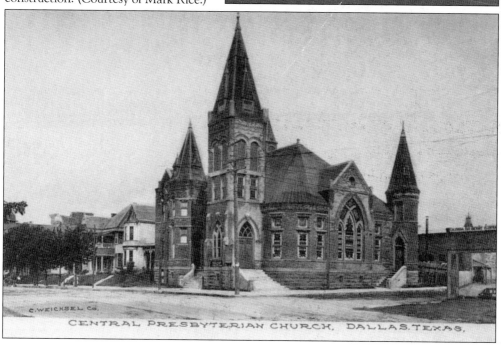

CENTRAL PRESBYTERIAN CHURCH, DALLAS, TEXAS.

This two-level drinking fountain, presented in 1907 by the National Humane Alliance, could accommodate horses with the larger basin on top as well as dogs at four lower-level indentations. Located near the middle of the intersection of Commerce, Cesar Chavez, and Jackson Streets in the Pershing Square commercial area on the east end of downtown, the infamous fixture was deemed a traffic hazard in 1992 and was subsequently moved to Dallas Heritage Village. (Courtesy of the *Dallas Morning News*.)

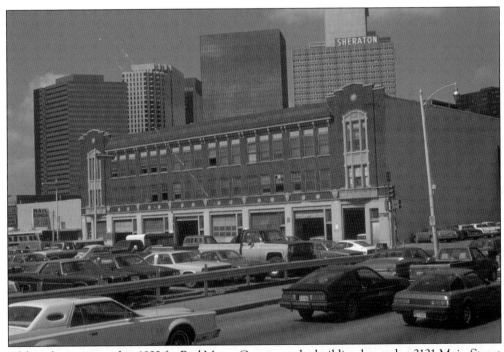

Although constructed in 1922 for Red Motor Company, the building located at 2121 Main Street housed the Central Fire Station beginning in 1928. Serving as a working fire station until 1963, the building was headquarters for the Dallas Fire Department until 1979. Despite assurances from the new owner that the well-loved building would be restored, demolition work began in December 1982. City officials, stunned that the owners had misrepresented their intentions, balked and attempted to halt the demolition. After tense negotiations, the three-story brick-and-terra-cotta front facade was salvaged and incorporated into a black-tinted glass design that popped up to six stories in the rear. The new building, finished in 1983, was considered a poor compromise by all parties involved.

Three

EAST DALLAS

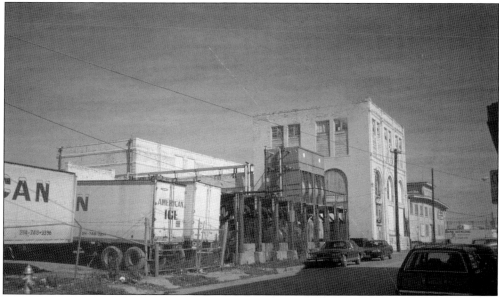

The American Ice House Building, know also as the Lemp Brewery, was a three-story brick structure with Romanesque arched windows. Constructed in 1890 for the Lemp Brewery of St. Louis, the structure was later joined by other additions and related construction that filled the block along Indiana between North Crowdus Street and Malcolm X Boulevard. Despite approval to begin the process for local landmark designation, a demolition permit was issued in error after a fire in July 1998. The entire site was reduced to rubble over the disgust of local preservationists in January 1999.

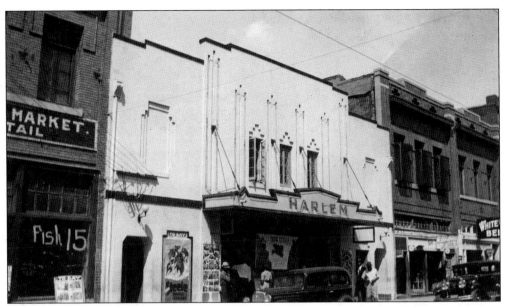

Known as the Palace until 1935, the Harlem Theater catered exclusively to the African American commercial district of Deep Ellum on the east end of downtown. The 500-seat Art Deco theater, located on Elm Street, survived until the late 1950s, when the entire block was taken down for the expansion of North Central Expressway. (Courtesy of Mary McCord/Edyth Renshaw Collection on the Performing Arts, Jerry Bywaters Special Collections, Hamon Arts Library, Southern Methodist University, Dallas, Texas.)

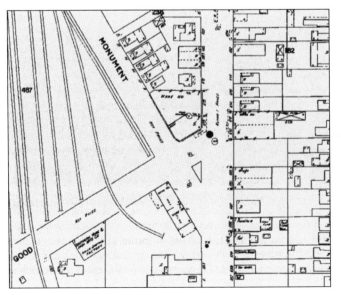

This 1905 Sanborn fire insurance map shows a triangular plot of land created by the intersection of Pryor (later Monument Street), Good, and Elm Streets. Known as Monument Plaza, the land was deeded in 1872 to the Dallas Confederate Monument Association for erection of a monument to Confederate war dead. When no monument was erected, the land was given to the city, which could never identify a use for the small parcel. The plaza was erased when Good-Latimer Expressway was constructed in 1952.

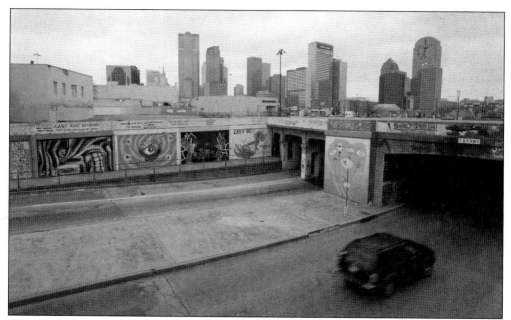

The Good-Latimer Expressway tunnel was built in 1930 to allow vehicular traffic to enter Deep Ellum uninterrupted by avoiding the Houston & Texas Central Railroad tracks. Serving in later years as a familiar gateway and artist palette, the tunnel was demolished in spring 2007 to accommodate light rail construction. (Courtesy of the *Dallas Morning News*.)

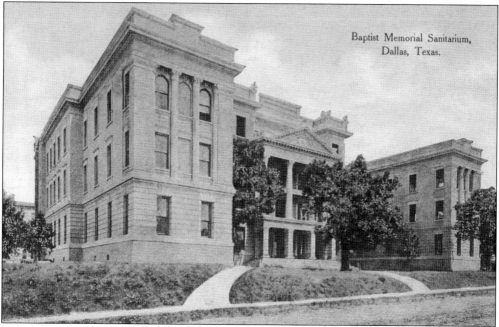

Baptist Memorial Sanitarium,
Dallas, Texas.

Texas Baptist Memorial Sanitarium became the most modern hospital in the Southwest when this 250-bed facility opened in 1909. Constructed at the corner of Junius and Hall Streets, the neoclassical structure designed by C.W. Bulger & Son survived many renovations until it was finally taken down for expansion of the renamed Baylor University Medical Center in the 1980s. (Courtesy of Mark Rice.)

Noted Dallas architect Herbert M. Greene designed this YWCA-affiliated boardinghouse on North Haskell Avenue in 1921. The handsome brick-and-stone Georgian structure, later owned by Dallas Theological Seminary and known as Proctor Hall, was taken down in 2007 by a new owner for a parking lot. (Courtesy of Craig Blackmon, FAIA.)

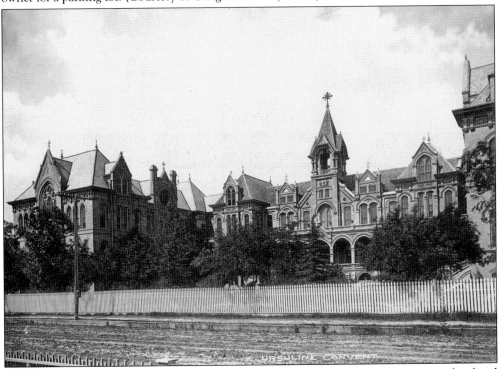

The Ursuline Convent was a High Victorian Gothic structure that filled a nine-acre site bordered by Live Oak Street, Haskell Avenue, Bryan Street, and St. Joseph Street. Begun in 1882 and completed in 1884, the girls' preparatory school is credited to famous Galveston architect Nicholas J. Clayton. Enlarged several times, the convent property was purchased in 1950, necessitating the Ursulines to relocate to another location, and the site was cleared. (Courtesy of the *Dallas Morning News*.)

While the majority of George Kessler's 1915 plan for the design of Exall Park was never fully executed, the park at Hall and Bryan Streets did include a wading pool, lily ponds, and wooded areas flanking Mill Creek. Named after Henry Exall, a founder of the Texas Industrial Congress, the park's formal amenities were gradually modified or eliminated, including the burying of Mill Creek and a new recreation center replacing the one constructed in the 1930s. (Courtesy of Park and Recreation Collection/Dallas Municipal Archives.)

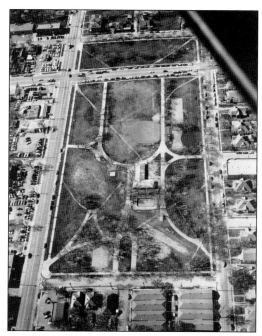

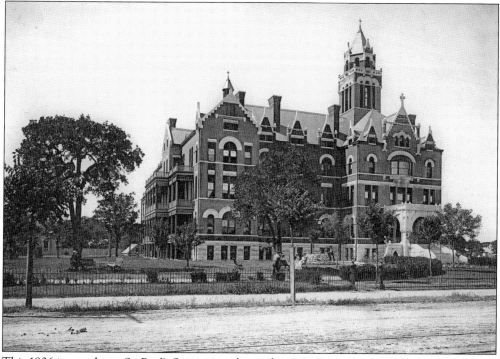

This 1906 image shows St. Paul's Sanitarium, located at 3121 Bryan Street. Dallas architect H.A. Overbeck designed the three-story Romanesque Revival structure in 1898 with features such as electricity, hot and cold running water (a first for Dallas), and a fireplace mantel in every room. Several additions to the imposing building kept St. Paul's Hospital functioning at this location until 1963, when a new facility opened at another site. The complex was demolished in 1968. (Courtesy of the *Dallas Morning News*.)

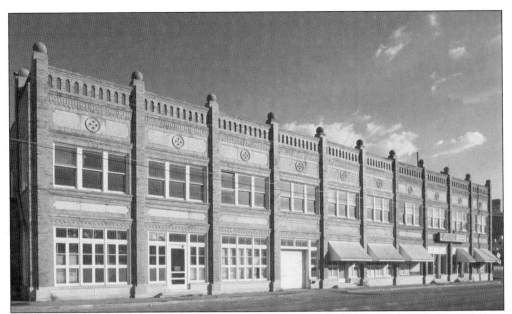

Fishburn's Laundry dominated the south side of Ross Avenue at the corner with Pavillion Streets. One of the first commercial buildings along Ross Avenue, the structure was built in 1907 as the main plant of the Fishburn's dry cleaning and laundry chain. The two-story brick-and-cast-stone building with iron carriage gates and horse stables was taken down on March 17, 2003, with local preservationists watching from across the street. (Courtesy of Craig Blackmon, FAIA.)

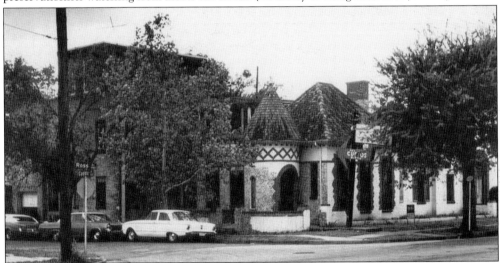

This Spanish-style structure at 3834 Ross Avenue, at the southwest corner with Caddo Street, was built in the 1920s as a private hospital. The one-story front half of the building was entered through a quaint rounded-turret entry feature, while a two-story rear addition with a third-level penthouse contained a large meeting area and space for ambulances. Known also as the Castle, the building served from 1972 to 1976 as the home of Metropolitan Community Church–Dallas, which would grow to become the Cathedral of Hope, the world's largest lesbian, gay, bisexual, and transgender church. After the church vacated the property, it became a curio shop and was ultimately demolished. (Courtesy of the Phil Johnson Archive Library at the Resource Center of Dallas.)

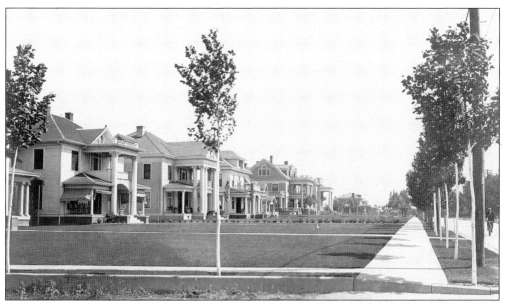

One of the greatest tragedies of Dallas's built environment is the loss of the residential structures along Ross Avenue. Known as Dallas's Fifth Avenue and Silk Stocking Row, Ross Avenue's eclectic collection of homes stretched from the northern limits of downtown to almost lower Greenville Avenue. Encroaching commercial development as early as the 1920s led to demolition after demolition of the fine residences until only three mansions remained. This view is of the corner of Ross and Carroll Avenues, looking northeast. (Courtesy of the *Dallas Morning News*.)

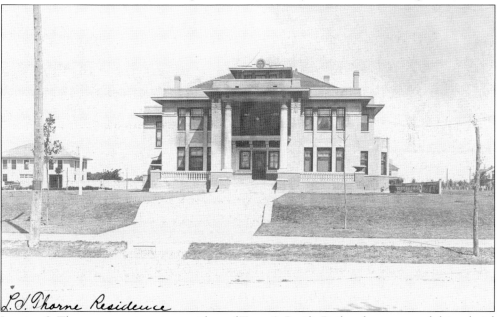

Lansing S. Thorne, executive vice president of Texas & Pacific Railroad, constructed this palatial mansion at the corner of Ross and Grigsby Avenues in 1908. Considered the last of the grand homes that lined Ross Avenue, the neoclassical and Prairie-style hybrid, featuring an impressive entry portico and porte cochere, was leveled in 1969 for a parking lot. (Courtesy of the *Dallas Morning News*.)

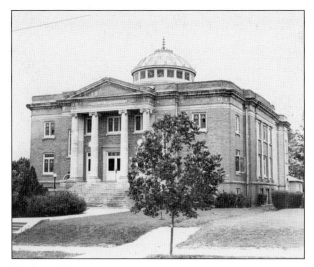

Formally opened on November 18, 1917, Ross Avenue Baptist Church was located at the corner of Ross Avenue and Moser Street. Designed by architects Van Slyke and Woodruff, the Classical Revival–style building featured a monumental staircase, a large pedimented portico supported by four Ionic columns, and a metal dome with exquisite stained glass on the interior. Ravaged by fire on March 29, 2002, the shell remained open to the elements until the small congregation decided to clear the site in June 2004. (Courtesy of the *Dallas Morning News.*)

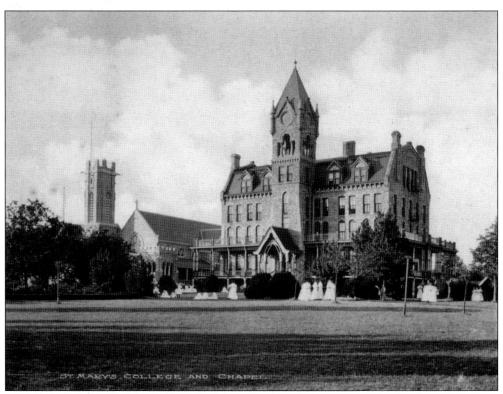

St. Mary's College, designed in the Victorian Gothic style by Dallas architect A.B. Bristol, was completed and opened for enrollment on September 10, 1889. The Episcopal private school provided higher education for many young women, including Claudia Alta Taylor, known more famously as Lady Bird Johnson. Bounded by Ross Avenue and Henderson, Garrett, and San Jacinto Streets, the first campus building, shown here, was leveled in 1948 after the college closed in 1929. The original chapel, to the left, was taken over by a downtown congregation and is still in use as St. Matthew's Cathedral. (Courtesy of the *Dallas Morning News.*)

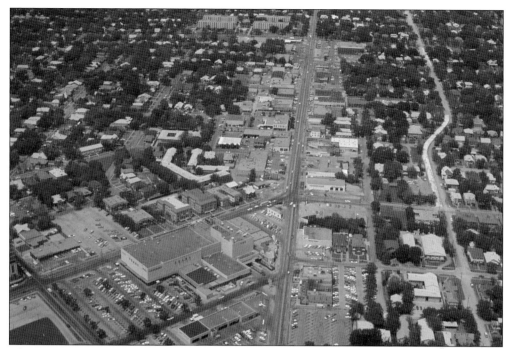

This 1980s aerial of the Ross and Greenville Avenue intersection shows the extent of the commercial and residential district that defines this portion of East Dallas. Dominated by the Sears, Roebuck & Company store and its accompanying shopping plaza, the district also contained several multistory apartment buildings clustered along Ross Avenue, near the center of the image. All these apartment buildings would be leveled in the 1990s for suburban style commercial development.

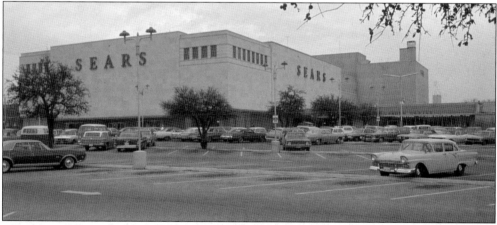

The three-story steel, stone, and masonry Sears, Roebuck & Company retail store at 5334 Ross Avenue opened with great fanfare on Thursday, September 4, 1947. At that time the second largest store in the Sears system, the massive structure with a limestone–and–diamond pink granite facade also featured no windows (except on the third floor), concealed fluorescent lighting, escalators, and marble-grey terrazzo floors. Five interior murals depicted Dallas and Texas agricultural and industrial life. New stores and demographic changes in the surrounding neighborhoods led to its closing in 1993; the building was demolished soon after and replaced with another suburban-style shopping center.

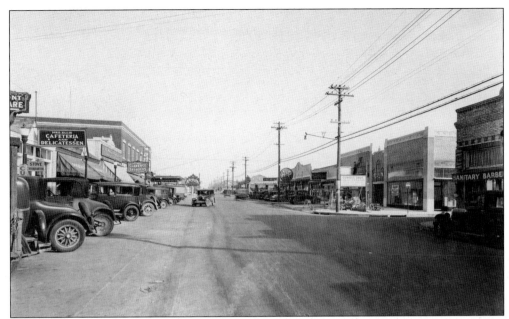

Known as Lower Greenville, the streetcar commercial area clustered around the Ross and Greenville Avenue intersection helped service the surrounding growing residential Belmont and Vickery Place neighborhoods. Signs for the A&P grocery store and the Arcadia Theater are visible in the center of this image taken in 1930. (Courtesy of the Texas/Dallas History and Archives Division, Dallas Public Library.)

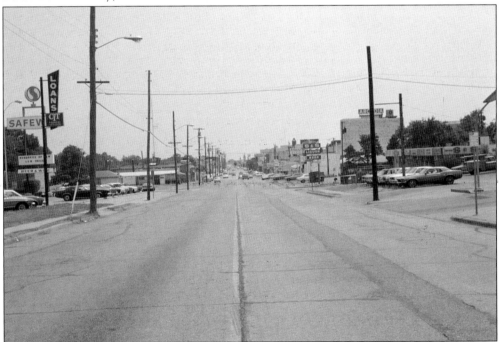

This 1970s view of the Lower Greenville retail district is taken from the corner of Greenville and Belmont Avenues looking south toward Ross Avenue. Familiar landmarks like Safeway grocery, S&S Liquor, and the rooftop sign of the remodeled Arcadia Theater are visible.

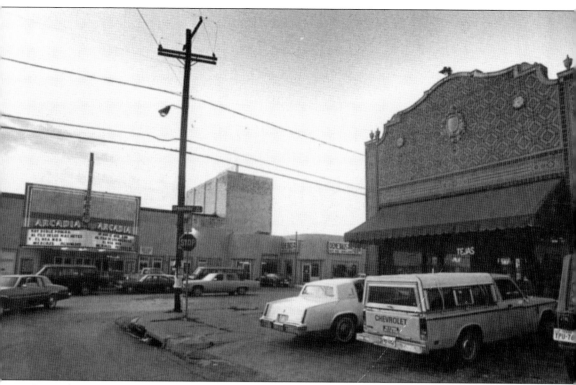

Opened in 1927 as a combination vaudeville theater and movie house, the Arcadia Theater was a familiar and well-loved anchor for the Lower Greenville neighborhood. Closing as a movie house in the early 1980s, the Arcadia morphed into a well-known live music venue that hosted such stars as Miles Davis, Metallica, and Nine Inch Nails. The theater space, along with the accompanying retail spaces fronting Greenville Avenue, was lost in a six-alarm blaze on the afternoon of Wednesday, June 21, 2006. The ruined complex was completely cleared within a couple of days. (Courtesy of the *Dallas Morning News*.)

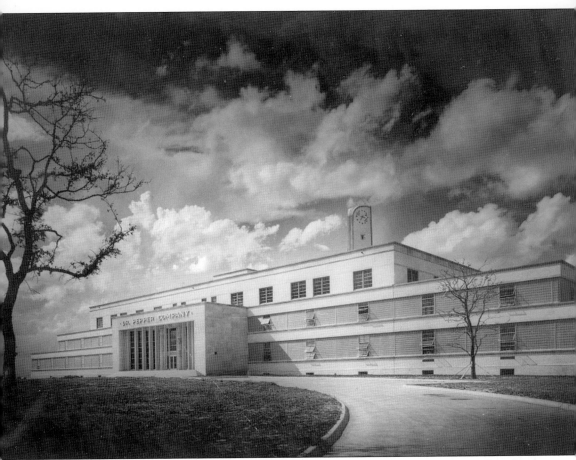

The Dr. Pepper National Headquarters was designed by Thomas, Jameson & Merrill Architects in 1946. Finished in 1949, the late Art Moderne building with its distinctive "10-2-4" clock tower, long horizontal roofline, curved corners at the entry, and glass block exterior faced an expansive front lawn with a circular drive off of Mockingbird Lane that led to the building entrance. Containing 252,772 square feet of administrative, laboratory, and manufacturing space, the complex was actually four stories in height, the lowest level below grade, giving the impression from Mockingbird of only a three-story structure. (Courtesy of the Texas/Dallas History and Archives Division, Dallas Public Library.)

This interior view shows the curvilinear forms and soaring windows of the main entry foyer of the Dr. Pepper National Headquarters. Although sympathetic additions were made to the building in 1972–1974, Dr. Pepper left the building in 1988, and the property was foreclosed on in 1990. Sold to an indifferent developer in 1993, the structure was demolished for new construction in 1997 despite many attempts to re-use the building and unprecedented local, state, and national outcry. The distinctive time and temperature sign, though altered, remains at the corner of Mockingbird and Greenville Avenue. (Courtesy of the Texas/Dallas History and Archives Division, Dallas Public Library.)

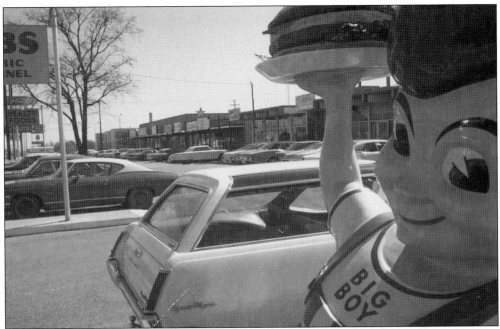

Kip's Big Boy, located at the southeast corner of Mockingbird Lane and Greenville Avenue, was a very popular hangout for residents of nearby neighborhoods and students at Southern Methodist University, located to the west down Mockingbird Lane. The building, along with its trademark chubby boy in red-and-white checked overalls holding a Big Boy sandwich (double-decker cheeseburger), was taken down in the 1990s for new commercial construction.

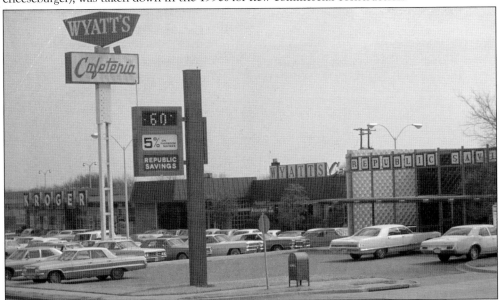

Wyatt's Cafeteria, Kroger Grocery Store, and Republic Savings and Loan were familiar anchors of the shopping strip located at Mockingbird Lane and Alderson Street. The structure housing Republic Savings and Loan, which failed in the 1988 savings and loan scandal, was demolished for newer bank construction. Although Wyatt's Cafeteria no longer operates and the Kroger relocated to a larger site across the street, the rest of the complex, though heavily modified, survives.

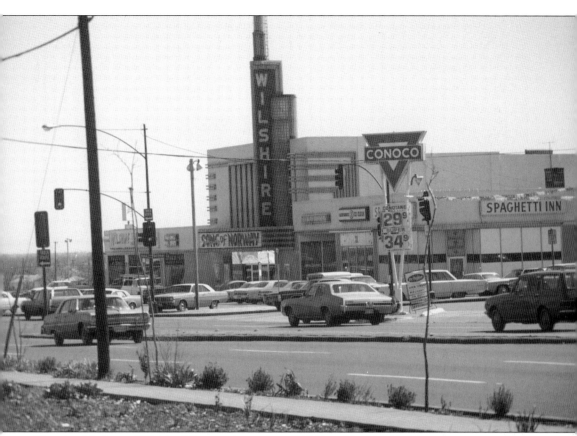

The Art Moderne Wilshire Theater, located at 6101 East Mockingbird Lane, was opened on October 4, 1946. Sporting a towering rounded glass block–and–neon tower and marquee, the Wilshire served the Mockingbird Lane commercial corridor for nearly 50 years before it was closed and ultimately demolished for new construction.

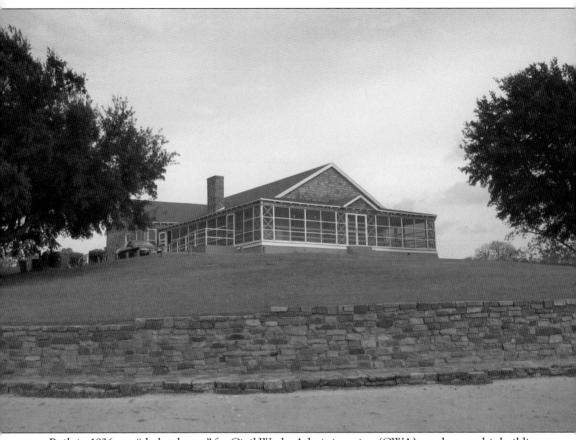

Built in 1936 as a "shelter house" for Civil Works Administration (CWA) employees, this building was soon taken over for use as a private clubhouse for the employees of Sol Dreyfuss of prominent downtown Dallas clothing retailer Dreyfuss & Son fame. The rambling wood-framed recreation building, located near Dreyfuss Point, was later turned over to the City of Dallas, and the Dreyfuss Club served as a beloved White Rock Lake landmark until it was engulfed in flames in October 2006. (Courtesy of Park and Recreation Collection/Dallas Municipal Archives.)

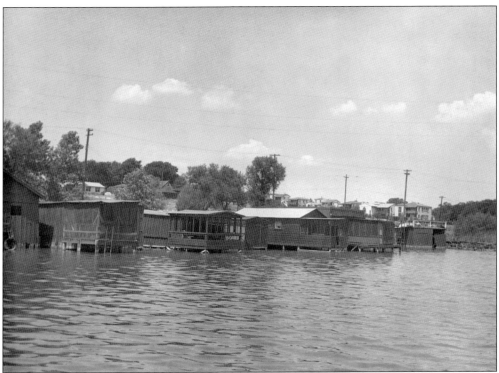

The City of Dallas allowed residents to pay a $1 lease to erect private boathouses along the shores of White Rock Lake beginning in the 1930s. All private structures, including these boathouses located on the west side of the lake, were removed from the lake shores in October 1952 after criticism that the public's access to the lake was limited due to their placement. (Courtesy of Park and Recreation Collection/Dallas Municipal Archives.)

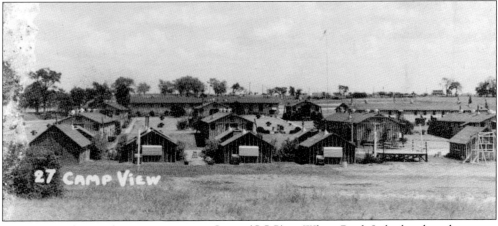

Recruits for the Civilian Conservation Corps (CCC) at White Rock Lake lived in this camp built by the Army in 1935. Located near Winfrey Point, the CCC camp included barracks for young men working on projects to beautify White Rock Lake, huts for educational and training purposes, a chapel, a dispensary, and a kitchen. After the CCC camp was closed due to the United States' entry into World War II, the site was used to house German prisoners of war and Southern Methodist University students before the last building was dismantled in August 1950. (Courtesy of Park and Recreation Collection/Dallas Municipal Archives.)

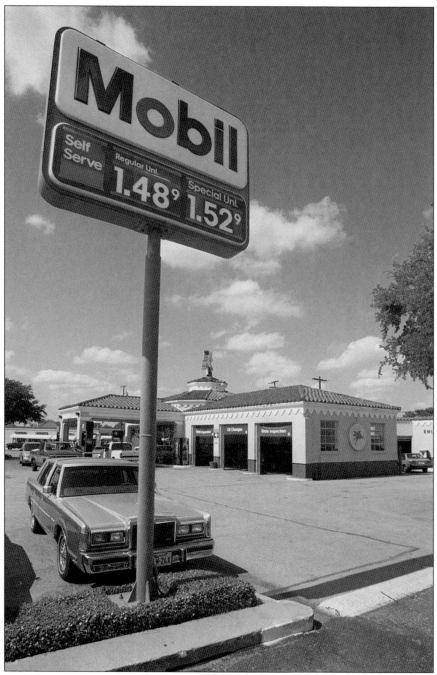

The Casa Linda Mobil gas station, designed as an integral part of the Casa Linda Plaza shopping center, was built in 1945. The red-tile-roofed, octagonal-shaped, Spanish-style station at the northeast corner of Garland Road and North Buckner Boulevard was a neighborhood landmark for decades before it was demolished in July 2003 for a bank branch. The iconic 11-foot rotating neon "Flying Red Horse" sign, displayed at the 1939 New York World's Fair, was removed and now resides at the Old Red Museum of Dallas County History and Culture. (Courtesy of the *Dallas Morning News*.)

Four

FAIR PARK AND SOUTH DALLAS

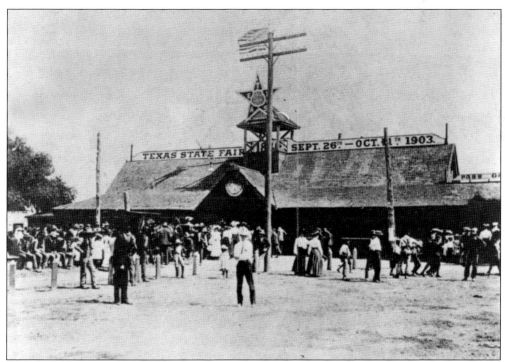

Crowds are lined up to enter the main entry for the 1903 Texas State Fair. The Texas State Fair and Dallas Exposition, created in 1886, became known as the State Fair of Texas in 1904. The main entry gate, shown here, was constructed in 1886 for the first fair. Located on Parry Avenue, this wooden structure was replaced in 1906 by a more substantial entry. (Courtesy of Preservation Dallas.)

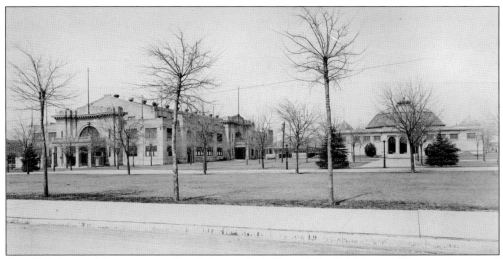

C.D. Hill designed the new State Fair Coliseum (at left) in 1910, while the neighboring Textile and Fine Arts Building was constructed in 1908. The coliseum, favored for its acoustics and abundant lighting, could seat 7,500 people and hosted numerous and varied activities. The Textile and Fine Arts Building, designed by Hubbell and Greene, had a crystal-paned dome and housed the Free Public Art Gallery of Dallas, the city's first permanent art museum. Both buildings were utilized for the 1936 Texas Centennial Exposition, with the coliseum receiving in 1935 a new Art Deco facade and the Textile and Fine Arts Building becoming a service and maintenance facility. The Conoco Hospitality House was located in front. While the coliseum survives today, the Textile and Fines Art Building was razed in 1958.

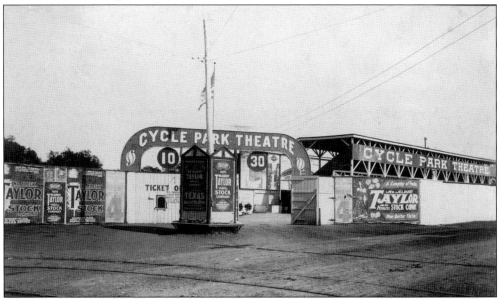

Built around 1890 to serve as a bicycle park for races, the Cycle Park Theatre was later converted to an outdoor summer theater that housed and presented productions by touring theater companies. Rebuilt after a disastrous fire in 1903, the facility survived until the Fair Park Auditorium was constructed in 1925. (Courtesy of Mary McCord/Edyth Renshaw Collection on the Performing Arts, Jerry Bywaters Special Collections, Hamon Arts Library, Southern Methodist University, Dallas, Texas.)

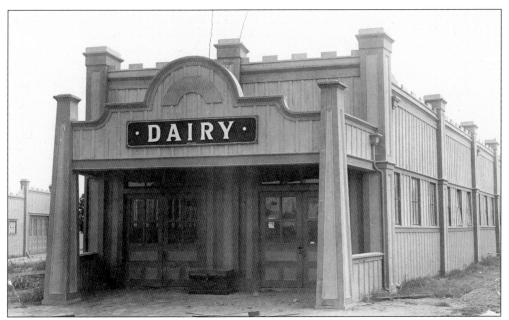

The State Fair of Texas Dairy Building, constructed in 1910, served as livestock facilities for the ever-growing annual event. The utilitarian building was soon considered inadequate, and the entire complex was taken down for new barns and other facilities finished in 1913. (Courtesy of the *Dallas Morning News*.)

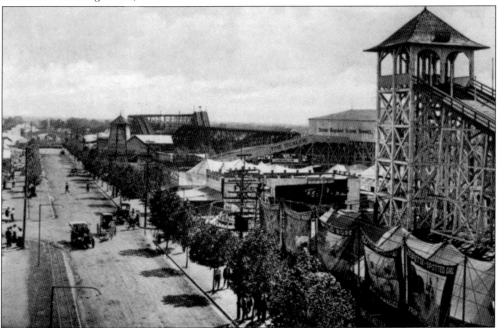

Beginning in 1906, new amusement rides were installed at Fair Park, including the 1,125-foot-long Scenic Railway; a water slide called Shoot the Chute, on the right of this photograph; and the second roller coaster at Fair Park, aptly named the Tickler. The majority of the structures, rides, and restaurant facilities along the "Pike" would be taken down in preparation for a new midway for the Texas Centennial Exposition.

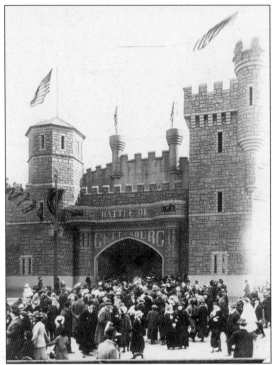

The Battle of Gettysburg drew impressive crowds when it opened for the 1930 State Fair of Texas. Housed in a theater that cost no more than $16,000, the Gettysburg cyclorama was one of many exhibits touting famous Civil War battles that toured the country during this period. (Courtesy of the *Dallas Morning News*.)

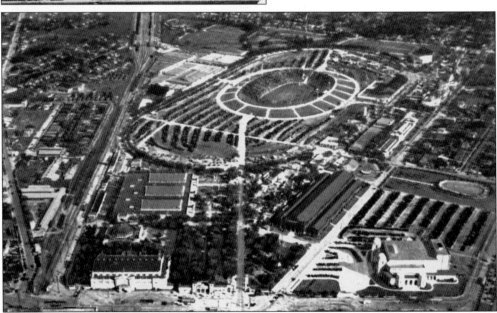

This 1930 aerial shows the placement of buildings and configuration of Fair Park before construction began for the 1936 Texas Centennial Exposition, which would transform the entire park. A grand esplanade with fountains and a reflecting basin would replace the 1906 George Kessler promenade with existing buildings receiving new facades to match George Dahl's Art Deco vision for the exposition. The original footprint of the new Fair Park Stadium, designed by Mark Lemmon, dominates the center of the image. Cars were allowed to park on what were once polo grounds. Renamed the Cotton Bowl in 1936, the stadium has since expanded several times.

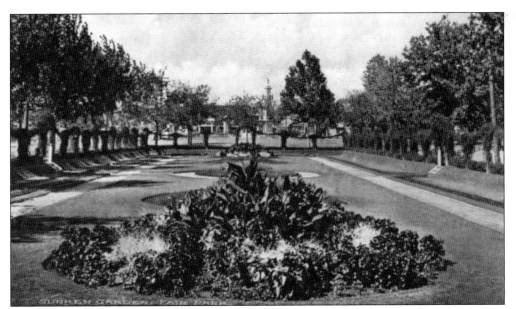

The Sunken Garden, in place by 1895, was located on the west side of the fairgrounds near Machinery Hall. The lowered garden area was ringed with trees and other foliage and featured large circular planting beds in the main lawn. The popular garden, with benches and a footpath, survived until the area was repurposed for the Centennial Exposition.

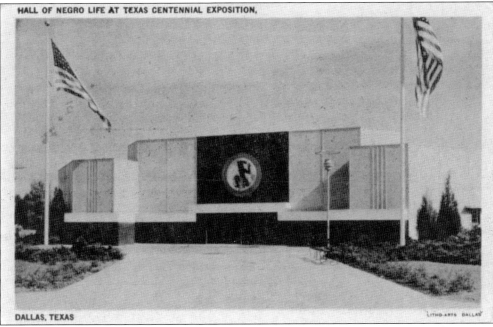

HALL OF NEGRO LIFE AT TEXAS CENTENNIAL EXPOSITION,

DALLAS, TEXAS

Dedicated on June 19, 1936, the day celebrated as the anniversary of the 1865 date when Texas slaves learned of emancipation, the Hall of Negro Life was the first federally funded exhibit hall devoted to African Americans at any World's Fair. The interior included murals by Harlem Renaissance artist Aaron Douglas. Despite its inclusion at the Centennial Exposition, considered revolutionary at the time, the Hall of Negro Life was the first building demolished after the Centennial closed. (Courtesy of Dallas Heritage Village.)

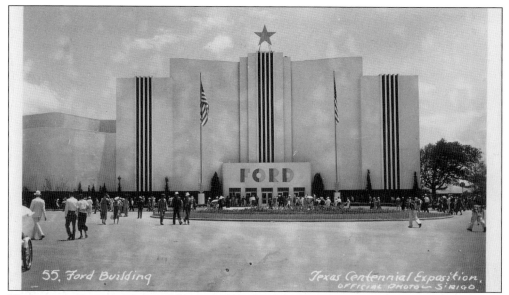

55. Ford Building Texas Centennial Exposition.
 OFFICIAL PHOTO — SIRIGO.

The largest and most expensive of the privately built exhibit halls at the Texas Centennial Exposition, the Ford Motor Company Building was organized around three sides of an open courtyard. The interior included a half-round Entrance Hall, a circular Diorama Hall, and an Industrial Hall that showcased 15 separate exhibits of manufacturing processes utilized by Ford and its major suppliers. The facade, accentuated with indirect neon lighting, also included a covered stage that featured bands to entertain visitors passing by. Renamed the Pan-American Palace for the 1937 Greater Texas and Pan-American Exposition, it is considered the greatest loss among those structures demolished immediately after the exposition closed in 1938. (Courtesy of Dallas Heritage Village.)

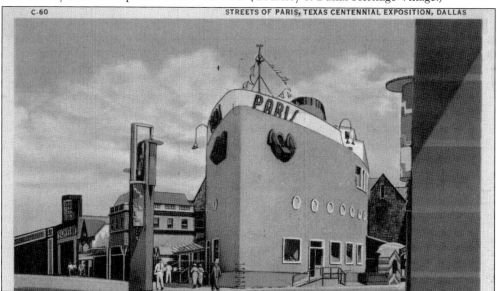

C-60 STREETS OF PARIS, TEXAS CENTENNIAL EXPOSITION, DALLAS

Streets of Paris, designed by George Dahl, was a replica of the SS *Normandie* and featured air-conditioned decks on three levels that allowed Centennial Club members exclusive access to watch the nude review in the open-air performance area below. Admiral Byrd's Little America, City of China, and Ripley's Believe It or Not were other educational exhibits that provided visitors with an exposure to other cultures, food, and architecture. (Courtesy of Dallas Heritage Village.)

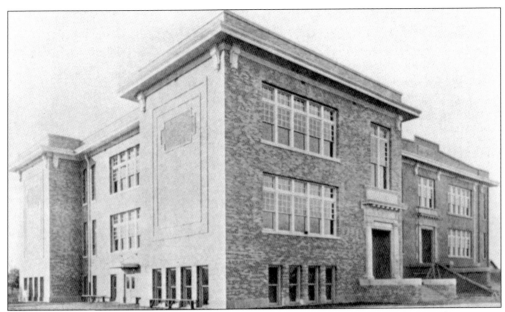

Oran M. "O.M." Roberts School was built in 1910 to help alleviate overcrowding in the growing Dallas public school system. This simple Classical Revival-style academic structure, located on East Grand and South Barry Avenues, served the neighborhood for over 100 years until the Dallas Independent School District demolished it in August 2011 for new academic construction.

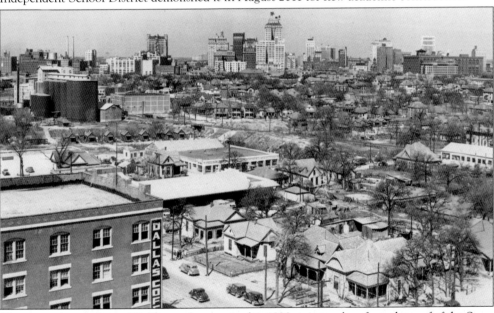

The impressive skyline of Dallas can be seen in this 1930s image taken from the roof of the Sears Distribution complex on South Lamar Street. In the immediate foreground are the remaining private residences of the Cedars neighborhood. Developed beginning in the 1870s, the Cedars became an enclave for the wealthy Jewish merchants of Dallas. The area rapidly declined in the 1920s as more industrial uses were allowed and downtown commercialization crept farther south. Most of the late-19th-century structures were gone by the 1970s. (Courtesy of the Texas/Dallas History and Archives Division, Dallas Public Library.)

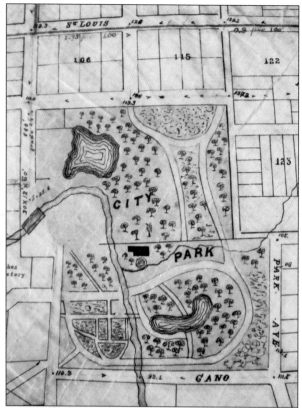

City Park was the first municipal park in Dallas, established in 1876 on land owned by Col. J.J. Eakins. Other adjacent land purchases created a 19-acre park by 1885. Extensive landscaping began in 1886, and by 1900, the park boasted roads and footpaths, several bridges over a branch of Mill Creek, a bandstand, and electric arc lamps. Tennis courts, a swimming pool, and a lighted softball diamond were all added by the 1940s.

The 1896 Confederate Memorial monument stayed in City Park until freeway construction took five acres of park space and necessitated its move to Pioneer Cemetery in 1961. The remainder of City Park was repurposed beginning in 1967, when Millermore, an Oak Cliff antebellum residence threatened with demolition, was moved to the site. Later joined by other endangered structures, the living history museum is now known as Dallas Heritage Village.

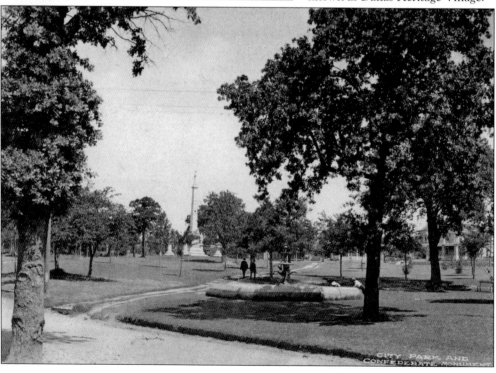

Philip Sanger's rambling mansion is featured in the upper left of this montage of prominent Dallas residences. Built in 1895 to mimic a New Jersey beach vacation house, the Cedars neighborhood structure survived until 1953. Other houses featured include the 1884 Thomas Field house on Peak Street in East Dallas; M.D. Garlington's 1889 Victorian on Maple Street and McKinney Avenue; and William H. Flippen's manse on Ross Avenue. (Courtesy of the *Dallas Morning News*.)

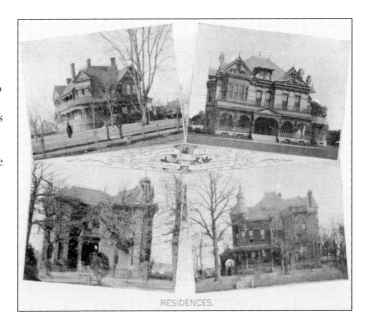

RESIDENCES.

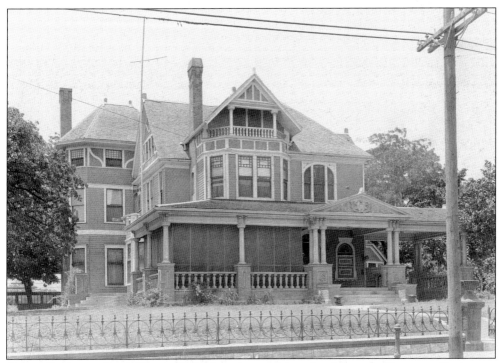

Originally designed in 1882 as a High Victorian mansion, the Alexander Sanger residence was remodeled in 1895 by Lang & Witchell. The more fashionable Prairie-style structure stood at the northwest corner of South Ervay and Canton Street until 1925, when it was taken down for commercial construction. (Courtesy of the *Dallas Morning News*.)

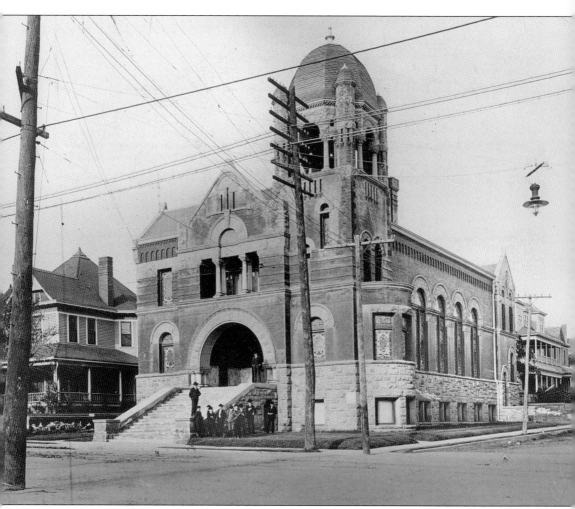

This Moorish-influenced synagogue, built by Temple Emanu-El in 1898, was constructed to replace the earlier Commerce Street temple and to serve the Jewish community in the Cedars. Located at the northeast corner of South Ervay and St. Louis Streets, the building featured elegant arched stained glass windows and an octagon-topped tower. When the surrounding families and the temple migrated farther south in 1913, this building became a Unitarian church. Freeway construction took the structure down in 1961. (Courtesy of Temple Emanu-El.)

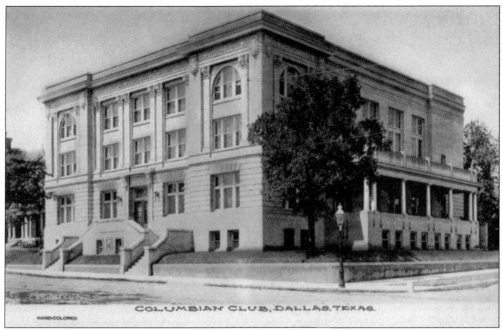

COLUMBIAN CLUB, DALLAS, TEXAS.

HAND-COLORED

Famous Dallas architecture firm Lang & Witchell's first collaborative design was the Second Renaissance Revival Columbian Club of Dallas. Founded as a private club in 1905 to serve the small but prominent Jewish citizens who settled in the Cedars neighborhood south of downtown, the four-story building was completed in 1907. Located on South Ervay Street at Pocahontas Street, the clubhouse was the hub of Jewish social life until destroyed by fire in 1930. (Courtesy of Mark Rice.)

The home of Mr. and Mrs. S.Q. Richardson was located at 1717 Richardson Street, near South Ervay in the southern section of the Cedars neighborhood. Built by Richardson, a well-known salt mine developer, in the 1880s, the three-story brick house had 12 fireplaces, reception halls on each floor, and a main floor halfway below ground level. Later serving as a clinic, a boardinghouse, and a morgue, the Victorian structure was lost when the majority of the area was developed for light industrial use beginning in the 1950s. (Courtesy of the *Dallas Morning News*.)

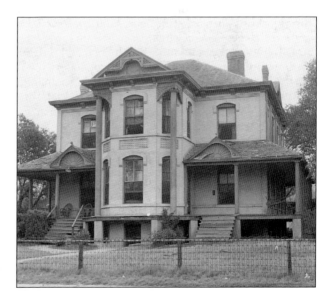

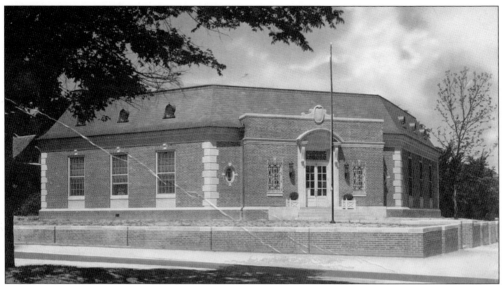

Built by Philip and Alexander Sanger for the burgeoning Edgewood addition close to Forest Avenue (now Martin Luther King Jr.), the Sanger Library branch was an eclectic blend of Georgian Revival with a few French influences, notably the distinctive slate mansard roof. Originally designed to front Harwood Street, the entry was placed on the corner with Park Row Avenue by architect Henry Coke Knight as a concession to the neighborhood. (Courtesy of the Texas/Dallas History and Archives Division, Dallas Public Library.)

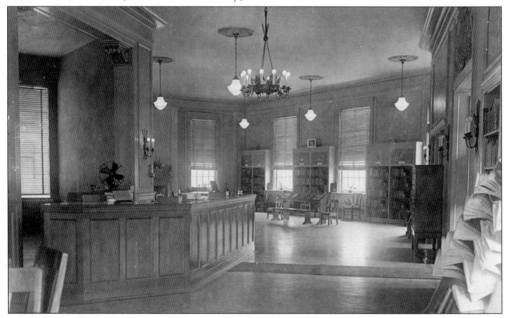

The library opened on February 1, 1932, with 3,000 volumes. The interior sported very handsome reading rooms for both adults and children. When the Sanger Branch was closed December 1967 for a new storefront branch on Forest Avenue, the property was sold to a private investor. The structure stood for less than 10 years before it was demolished in 1976. The site today is a vacant lot with remnants of the redbrick retaining wall defining the corner. (Courtesy of the Texas/Dallas History and Archives Division, Dallas Public Library.)

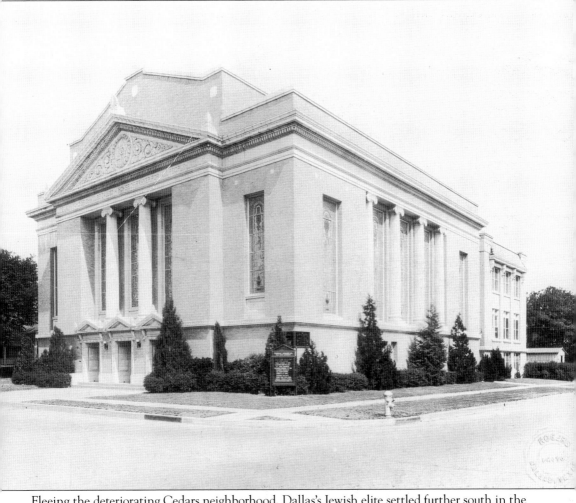

Fleeing the deteriorating Cedars neighborhood, Dallas's Jewish elite settled further south in the Edgewood addition. Temple Emanu-El followed with this third house of worship at the corner of South Harwood Street and South Boulevard. The majestic neoclassical structure designed by the architecture firm of Hubbell and Greene was finished in 1917. Abandoned in 1957 when the temple moved to its new Northwest Highway location, the building survived until 1972, when it was demolished for freeway construction. (Courtesy of Temple Emanu-El.)

Erected in the first wave of expansion for the school system at the beginning of the 20th century, Colonial Hill School was completed in 1903. A modified Romanesque Revival–style structure, Colonial Hill had decorative elements like arched windows, a recessed porch, and a bay window over the main entry. The building, standing at the corner of Pennsylvania Avenue and Wendelkin Street, served the surrounding residential sections until it was replaced with a new academic campus in the 1980s. (Courtesy of the *Dallas Morning News*.)

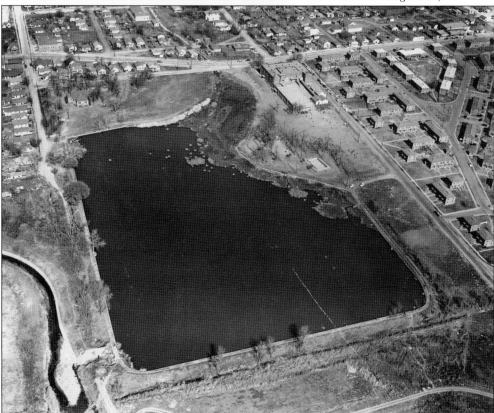

The formerly private Wahoo club and lake was purchased in 1924 to create Wahoo Park, located at the corner of Spring Avenue and Foreman Street in the Frazier Court neighborhood. By 1938, Wahoo Park had received a number of improvements, including a wading pool, comfort station, and two tennis courts as well as a WPA community building, landscaping, plantings, and walks. While the park, renamed for civil rights activist Juanita Craft, survived with the addition of a new recreation center in 1964, the 12-acre fishing lake was drained and filled in. (Courtesy of Park and Recreation Collection/Dallas Municipal Archives.)

Five

OAK CLIFF

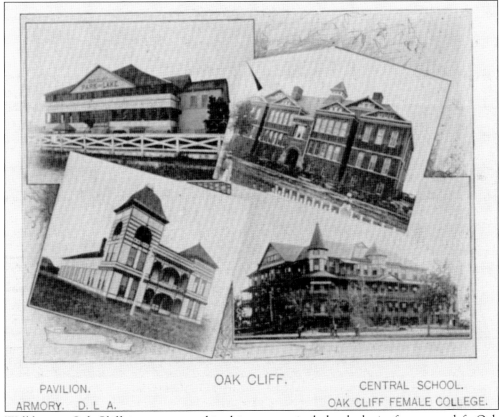

PAVILION.
ARMORY. D. L A.
OAK CLIFF.
CENTRAL SCHOOL.
OAK CLIFF FEMALE COLLEGE.

Well known Oak Cliff sites represented in this montage include, clockwise from upper left, Oak Cliff Summer Opera Pavilion, opened by Thomas Marsalis in 1889; Dallas Artillery Armory; Oak Cliff Central High School, designed by James Flanders at the corner of East Tenth and Patton Streets; and Oak Cliff College for Young Ladies, built in 1889 as the Park Hotel. All would be gone by 1945. (Courtesy of the *Dallas Morning News*.)

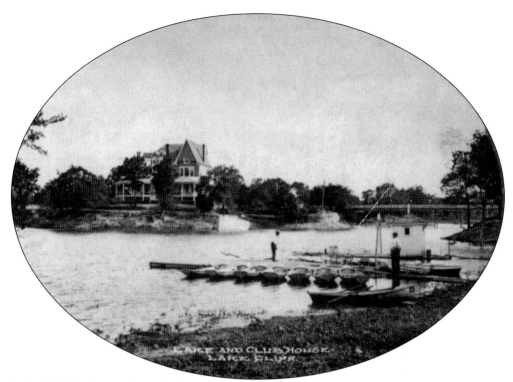

Lake Cliff Park opened in 1906 on 50 acres at the southeast corner of Zang and Colorado Boulevards. The clubhouse and restaurant, known as Cliff Café, sat on a small rise overlooking the lake. This afforded a perfect view of the surrounding sites that were constructed as part of the development.

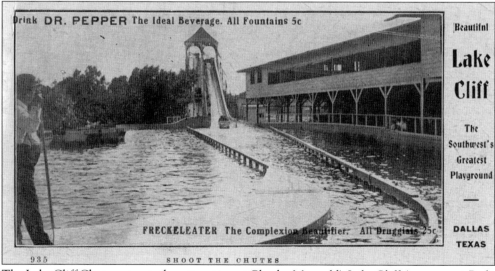

The Lake Cliff Chutes was another attraction at Charles Mangold's Lake Cliff Amusement Park, billed as the "Southwest's Greatest Playground." A casino, floating pool, numerous amusement rides, and an opera house were all built by Mangold and his investors in order to entice surrounding citizens to come to the park to cool down and relax during the hot Texas summers. (Courtesy of Dallas Heritage Village.)

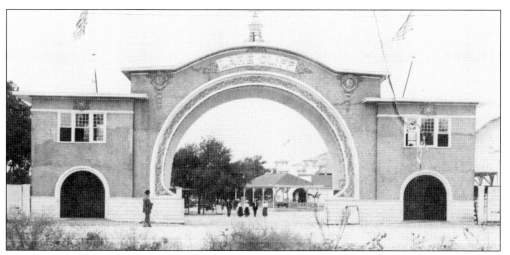

The elegant Sullivanesque entry arch was the first thing passengers saw as they unloaded from the streetcar to enjoy the sights at Lake Cliff Park. Purchased in 1914 for use as a city park, the majority of the buildings were dismantled and moved to other areas around the city.

Originally envisioned as part of George Kessler's 1919 master plan for Lake Cliff Park, it was not until 1934 that the Wynne Woodruff–designed rose garden was completed. Reworked and improved by WPA workers in the 1940s, the rose garden, along with most of the surrounding park, fell into disrepair during severe budget cuts in the 1980s. (Courtesy of Park and Recreation Collection/Dallas Municipal Archives.)

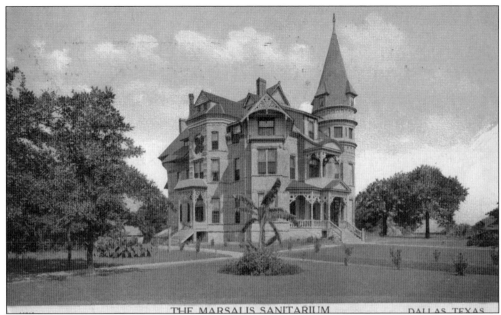

Thomas L. Marsalis, known as the main developer and promoter of Oak Cliff, constructed this regal Queen Anne residence in 1889. Located at the corner of Marsalis Avenue and Colorado Boulevard, which was considered too far out of Dallas for his wife, the structure was sold in 1904 and became known as the Marsalis Sanitarium. It burned to the ground in 1915. (Courtesy of Dallas Heritage Village.)

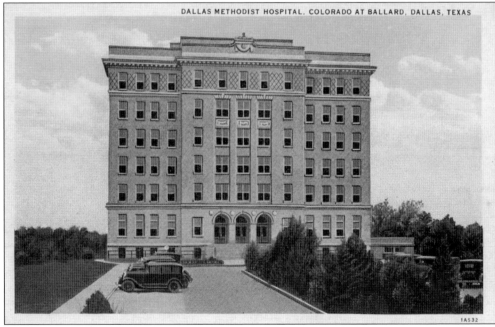

Founded in 1924, the seven-story, fireproof Dallas Sanitarium was built in 1927, providing Oak Cliff with a modern hospital facility. Later renamed Methodist Hospital, the structure was remodeled and expanded beginning in the 1940s, with demolition of the original building occurring in 1994. (Courtesy of Dallas Heritage Village.)

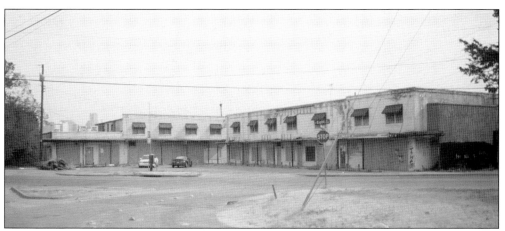

Townview Center, developed in 1951, was a gathering spot for the surrounding African American neighborhoods immediately south of the Trinity River. The complex, located at 1401 East Eighth Street, included a movie theater called the Star as well as a grocery store and a three-story residential component. It was demolished in the fall of 2000.

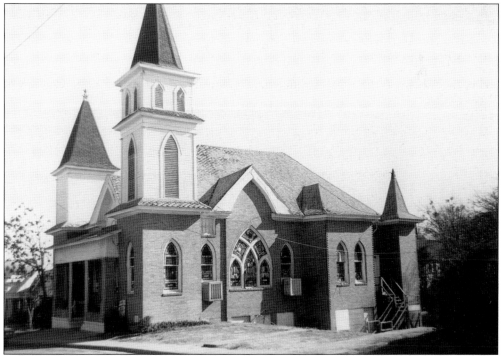

At the center of the Tenth Street neighborhood, the Gothic Revival Sunshine Elizabeth C.M.E. Church was built in 1911 using timber from the original church erected in 1889. Located at 1026 East Tenth Street, the twin steeples of the oldest black church in Oak Cliff were a familiar sight to motorists zooming along Interstate Highway 35. The first Oak Cliff structure designated a City of Dallas landmark, the building steadily deteriorated after the congregation moved out in the 1970s. The church had several beautiful stained glass windows dating from 1911 that were designed and installed by Dallas Art Glass. The windows were taken out of the building by vandals and scavengers before the congregation had the building demolished on March 15, 1999. (Courtesy of Kate Singleton.)

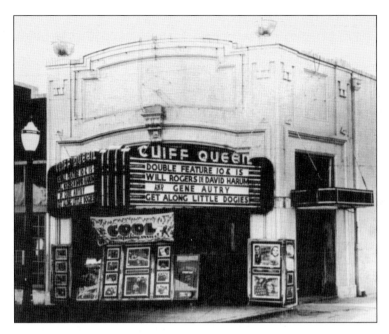

Named after its sister property in downtown Dallas, the Cliff Queen Theater was built in 1914 in the 600 block of East Jefferson Boulevard. One of the first theaters in Oak Cliff that ran motion pictures, the Cliff Queen was a popular matinee movie house. The Cliff Queen closed in 1948 and was demolished in 1958. (Courtesy of the Texas/Dallas History and Archives Division, Dallas Public Library.)

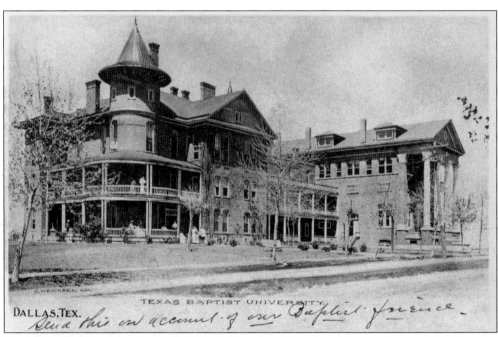

Texas Baptist University, located at Ninth Street and Lancaster Avenue, began in 1896 as the Patton Seminary, established by Dr. E.G. Patton. Room and board was limited to 30 students who learned literary arts, music, elocution, and physical culture. The Southern Baptist Church acquired the school in 1905, renaming it Texas Baptist University. Chartered in 1906, the school opened with more than 200 students. The First Baptist Church of Oak Cliff met in the school auditorium for a brief period after the school fell into receivership in 1912 and was sold. (Courtesy of Mark Rice)

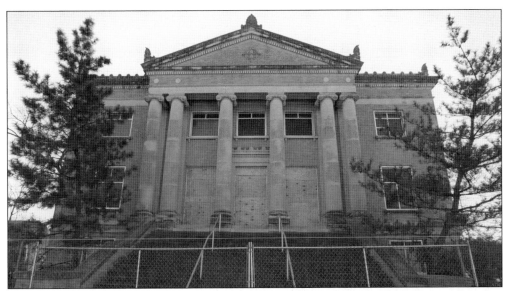

Standing at the corner of East Tenth and Crawford Streets, Oak Cliff Christian Church was designed by Fort Worth architects Van Slyke and Woodruff in 1916. The looming neoclassical structure with its monumental staircase and massive columns served numerous congregations before the Dallas Independent School District purchased and leveled the site for new school construction in October 2010. (Courtesy of the *Dallas Morning News*.)

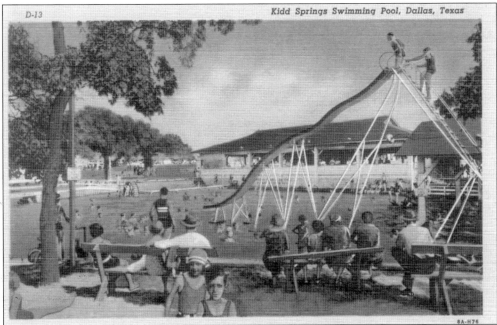

Kidd Springs Park began as a private fishing and boating club in 1895 on land owned by Col. James W. Kidd. The natural spring–fed waters were opened to the public in 1910, and its rise as an amusement destination culminated in the largest bathing pavilion in the South, a roller skating rink, and a Ferris wheel. The "Coney Island of Oak Cliff" was dismantled steadily over the years after acquisition by the City of Dallas as a public park. (Courtesy of Park and Recreation Collection/Dallas Municipal Archives.)

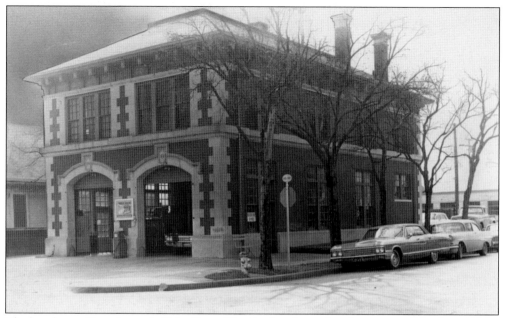

The handsome Georgian-style Tyler Street Fire Station, located at the corner of Tenth and Tyler Streets, was opened in June 1914. Known as Old 14, the building continued to serve and protect the surrounding neighborhoods until new, more modern fire stations built around Oak Cliff in the 1960s necessitated its closing. (Courtesy of the *Dallas Morning News*.)

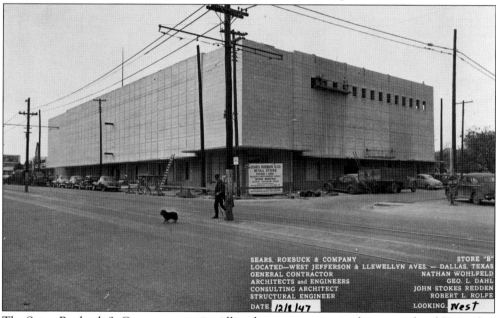

SEARS, ROEBUCK & COMPANY — STORE "B"
LOCATED—WEST JEFFERSON & LLEWELLYN AVES. — DALLAS, TEXAS
GENERAL CONTRACTOR — NATHAN WOHLFELD
ARCHITECTS and ENGINEERS — GEO. L. DAHL
CONSULTING ARCHITECT — JOHN STOKES REDDEN
STRUCTURAL ENGINEER — ROBERT L. ROLFE
DATE 12/8/47 — LOOKING West

The Sears, Roebuck & Company store is well under construction in this image dated December 8, 1947. Located at the corner of West Jefferson Boulevard and Llewellyn Avenue, this "Store B" prototype replaced an early Sears store located on East Jefferson, closer to downtown. This sprawling department store served at this location until it moved to Red Bird Mall in 1975. Notice the old overhead electric streetcar lines and tracks in the street. (Courtesy of the Texas/Dallas History and Archives Division, Dallas Public Library.)

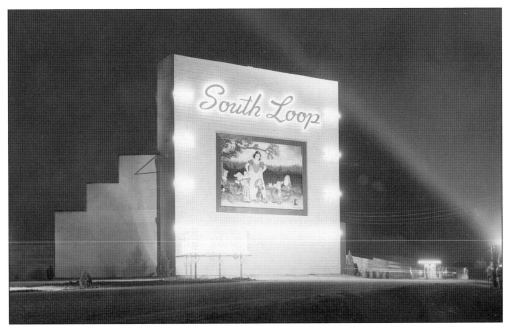

The South Loop Drive-In, located along East Ledbetter Drive close to Interstate 45, was an immediate landmark when it opened in 1950. The original screen, destroyed by a windstorm in 1956, featured a mural of Snow White and the Seven Dwarfs. The single-screen South Loop was lost by 1968. (Courtesy of the *Dallas Morning News*.)

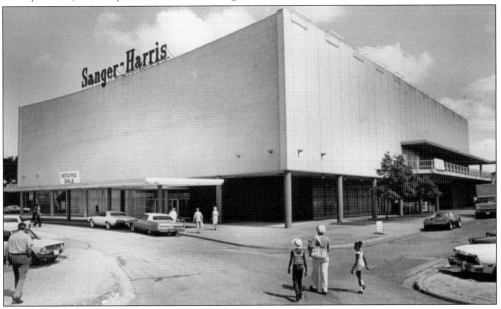

A modern Sanger-Harris store anchored the A. Harris shopping center located at the corner of South Beckley Avenue and West Kiest Boulevard. Developed in 1955, the center also housed several other well-known retail outlets, a cafeteria, and a supermarket. When Sanger's left for Red Bird Mall in 1975, the other businesses eventually followed suit, and the complex was purchased by the Dallas Independent School District for use as educational space. (Courtesy of the *Dallas Morning News*.)

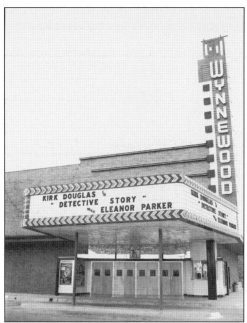

Built in 1951, the Wynnewood Theater was considered one of the gems in the expansive Wynnewood shopping and housing development located at the corner of Zang Boulevard and West Illinois Avenue. Designed by H.F. Pettigrew and John Worley, the theater featured distinctive signage, a crying room for babies, and a circular lobby. Closed in 1983, the Wynnewood was leveled in 1999. (Courtesy of the Texas/Dallas History and Archives Division, Dallas Public Library.)

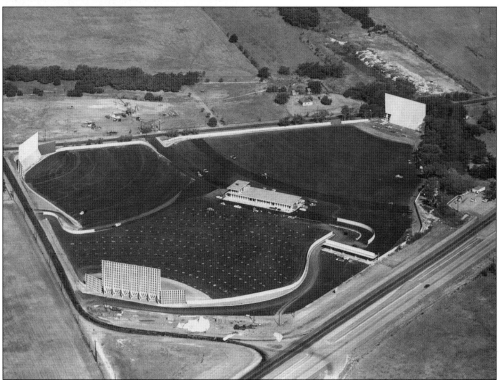

The triple-screen Astro Drive-In was located at the corner of Loop 12 and West Kiest Boulevard. The world's first fully automated drive-in, the Astro also had the largest screen in the Western Hemisphere when it opened 1969. Thriving due to a prime location and loyal patronage, the Astro was the last operating drive-in in the area when it was lost to fire the night before Thanksgiving 1998. (Courtesy of the *Dallas Morning News*.)

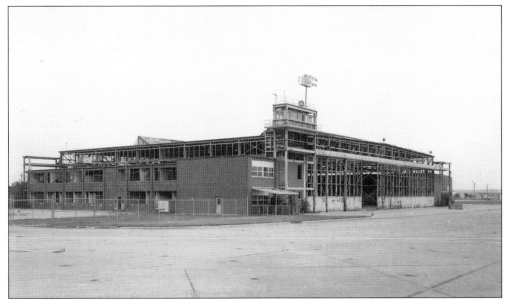

The maintenance hangar at the Naval Air Station Dallas complex, later known as Hensley Field, was finished in 1941. Constructed for a cost of $10,411 and designed by the Atlanta, Georgia, architecture and engineering firm Robert Company, the extensive metal truss system, wood roof, and lack of ornamentation were characteristic of the Bauhaus style of architecture. Known also as Building 20, the structure was taken down in 2010 after decades of neglect and vandalism.

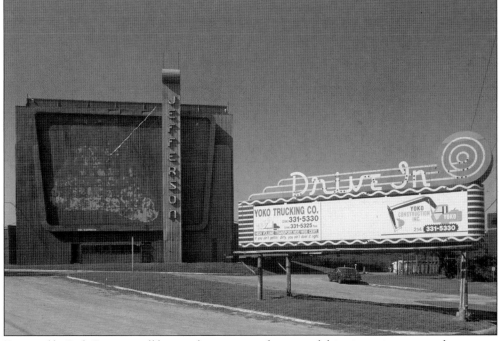

Designed by Jack Corgan, well known for numerous theater and drive-in projects across the postwar Southwest, the Jefferson Drive-In was opened in 1949. Featuring one screen with space for 600 cars, the streamline moderne Jefferson, with its iconic neon light display, was shuttered for good in 1990 and demolished in August 2004. (Courtesy of Craig Blackmon, FAIA.)

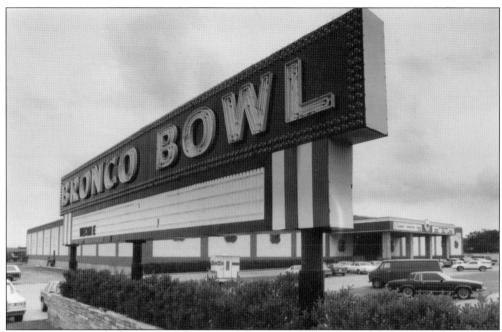

Actress Jayne Mansfield headlined a grand opening show at the Bronco Bowl in 1962. Located at 2600 Fort Worth Avenue, the Bronco Bowl was an entertainment juggernaut with slot cars, bowling, archery, pool, and golf. The facility was also well known as a music venue and attracted such varied artists as Bruce Springsteen, U2 , Metallica, and REM. The Bronco Bowl was shuttered in 2003 and the site cleared for retail construction. (Courtesy of the *Dallas Morning News*.)

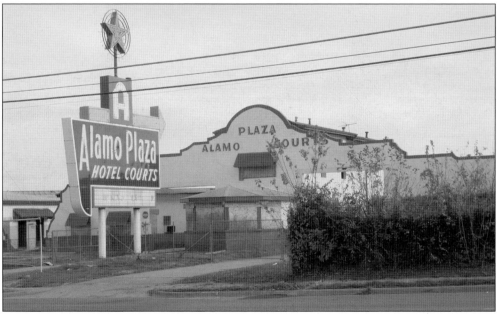

The distinctive Mission Revival Alamo Plaza Hotel Court was one of the numerous tourist courts and motels that sprang up along Fort Worth Avenue's approach to downtown Dallas. Opened in 1940, the Alamo Plaza, along with its trademark scalloped Alamo parapet, survived until 2010, when it was demolished for new mixed-use development.

Six

UPTOWN AND NORTH DALLAS

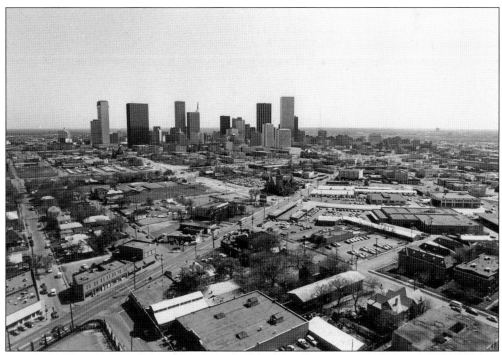

This mid-1970s aerial shows the low-rise buildings and parking lots that dominated this portion of Uptown until the main lane construction of Woodall Rodgers Freeway and building boom of the 1980s began to transform this section of the city. While a majority of the smaller commercial structures visible along McKinney Avenue, running toward the bottom of the photograph, are still standing, the majority of everything else has been replaced by luxury high-rise residential and commercial construction.

The Paul Lawrence Dunbar Branch opened in 1931 as the first library branch built to accommodate the city's burgeoning black community. Located at the corner of Thomas Avenue and Worthington Street, the L-shaped masonry building with decorative stone work and large casement windows continued to serve the neighborhood until 1959, when increasing commercial and industrial constraints from the ever-expanding downtown district to the south led to the overall decline of State-Thomas as a residential neighborhood. (Courtesy of the Texas/Dallas History and Archives Division, Dallas Public Library.)

St. Ann's School was opened in 1927 in a two-story masonry building that faced Turney (now Harry Hines) Boulevard. Expansions in 1946 led the school and neighboring Our Lady of Guadalupe Church to become the epicenter of Catholic life in Little Mexico until the merging of the parish with the Cathedral of Sacred Heart in 1965 and subsequent school closing in 1975. Although the original elementary school portion was designated a city landmark in 1999, the rest of the complex, aside from the Virgin of Guadalupe tile mosaic installed in 1946, was razed in 2004. St. Ann's School, along with the nearby Luna Tortilla Factory and Pike Park, are the only major historic remnants of the once-thriving Little Mexico neighborhood.

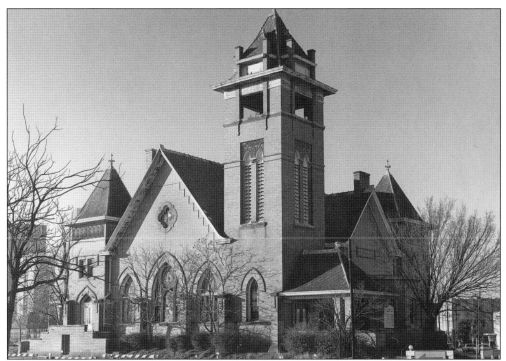

Anchoring the corner of McKinney Avenue and Pearl Street, James Flanders's masterpiece Trinity Methodist Church was an impressive blend of Chicago School and Prairie styles. Completed in 1904, the structure was well known for its soaring entry tower, large Gothic pointed arched windows and intricate, Sullivanesque stone frieze detailing. Closed as a church in 1974, the same year it became Dallas's first listing in the National Register of Historic Places, Trinity Methodist Church also became the first individual city landmark in February 1976. Gutted by fire in November 1981, the ruins were finally taken down in July 1985 for a drive-in bank.

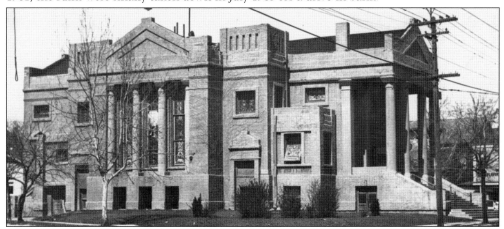

The original dome of the McKinney Avenue Baptist Church had already been removed when this image was taken in the late 1920s. Charles William (C.W.) Bulger designed this massive columned edifice in 1906. Beginning in 1937, the well-known neighborhood landmark served as a house of worship for multiple congregations, an antique store, and finally as the Dallas location for Hard Rock Café. The heavily altered structure became a victim of speculative demolition over a weekend in 2008. (Courtesy of the *Dallas Morning News*.)

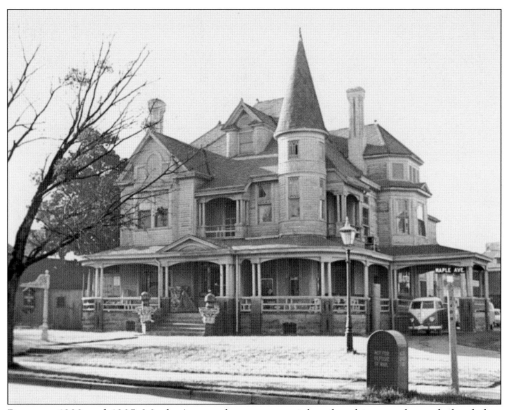

Between 1888 and 1905, Maple Avenue became a social and architectural wonderland that rivaled Ross Avenue and foretold of Dallas's growing march toward the north. Among those fashionable residences was the Weaver House, built by John C. Weaver in 1898. Located at the southeast corner of Maple and Alice Street, the residence was noteworthy for its distinctive round corner turret, spacious wraparound porch, and porte cochere. The Dallas Art Institute, which operated the neighboring Alice Street Art Carnivals, occupied the house in the 1930s. In 1969, the structure was the last of the Maple Avenue Victorians to be torn down. (Courtesy of the *Dallas Morning News*.)

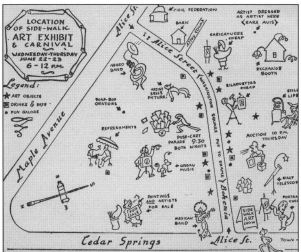

This whimsical map shows the offerings available during the 1933 Alice Street Carnival. Jerry Bywaters, along with fellow "Dallas Nine" notables, started the Carnival in 1932 to publicize local artists and champion the Dallas Regionalist movement. The festival was renamed and moved to Fair Park in 1938, and Alice Street disappeared completely when the Crescent complex was constructed in 1986. (Jerry Bywaters Collection on Art of the Southwest, Bywaters Special Collections, Hamon Arts Library, Southern Methodist University, Dallas, Texas.)

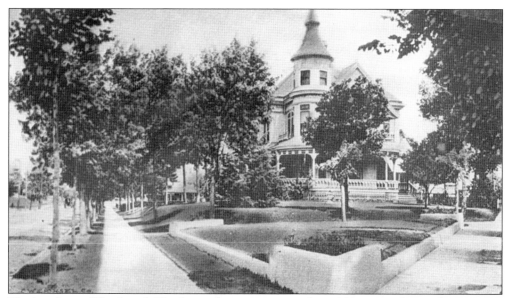

The handsome Woodworth-Knight residence, constructed in 1889, sat on the northeast corner of Maple Avenue and Cedar Springs. Owned originally by C.S. Woodworth, a founder of Dallas's lucrative lumber industry, the Queen Anne–style house was purchased by Robert E. Lee Knight in 1898. The structure, with its corner turret and wraparound porch, was taken down in 1942. (Courtesy of the *Dallas Morning News*.)

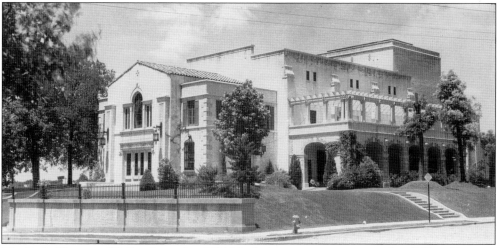

The Little Theatre of Dallas, located at 3104 Maple Avenue, was constructed in 1927 and became home to one of the best regional playhouses in the 1930s and early 1940s. Designed by Henry Coke Knight, the building was purchased by Joaquin Jose "J.J." Rodriguez in 1943 to serve as a Spanish movie house and community meeting space for the nearby Little Mexico neighborhood. It was renamed Theatro Pan Americano, and later Cine Festival, and Rodriguez continued showing Spanish-language movies until he closed the doors in 1983. Concerned by a movement among the historic preservation community to seek city historic designation, the commercial real estate company that purchased the property demolished the handsome Spanish–style structure early on a Sunday morning. (Courtesy of Mary McCord/Edyth Renshaw Collection on the Performing Arts, Jerry Bywaters Special Collections, Hamon Arts Library, Southern Methodist University, Dallas, Texas.)

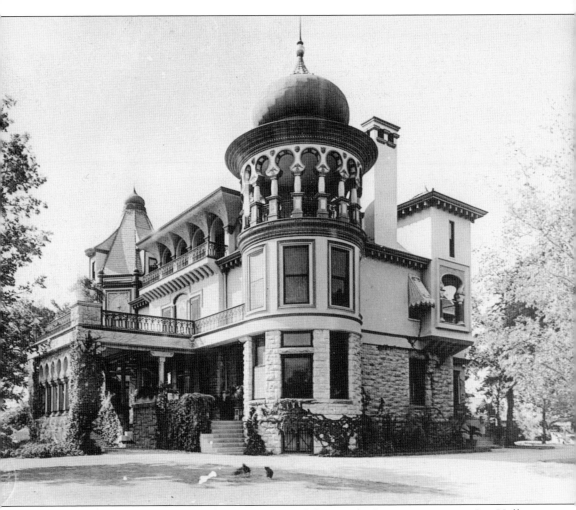

Perhaps the finest and certainly most exotic of the Maple Avenue mansions, Ivy Hall was completed in 1890. Railroad construction magnet George M. Dilley spared no expense when constructing the structure, which included an eclectic selection of turrets, a Kremlin-style onion dome, and a coach house that was larger than most houses in Dallas at the time. Located at the southwest corner of Maple Avenue and Wolf Street, the Moorish manse became too expensive to maintain and was leveled in 1924 for the extant Maple Terrace apartment building. (Courtesy of Preservation Dallas.)

Considered one of architect Harwood K. Smith's finest designs, this 1959 office building was located at 2505 Turtle Creek Boulevard. The single-story buff-and-orange-brick structure featured an entry area accentuated by floating entry canopies and landscaped outdoor spaces. The building was taken down early on a Sunday morning in April 2008 for speculative commercial construction, ironically the same day an article calling it one of Dallas's best examples of mid-century modern architecture was published in the *Dallas Morning News*. (Courtesy of Craig Blackmon, FAIA.)

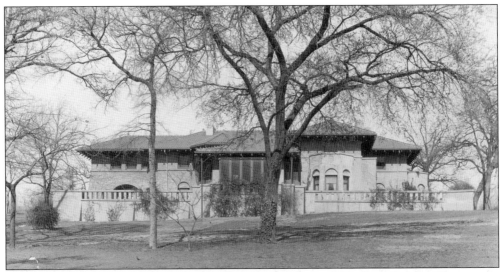

Architect J. Edward Overbeck designed this Mission-style residence for Col. John Trezevant in 1907 at the northwest corner of Turtle Creek Boulevard and Gillespie Street. One of the first mansions built along Turtle Creek, it became the infamous Cipango Club in 1949. Frank Sinatra, Judy Garland, and John Wayne, along with numerous local celebrities and legends, would come to the Cipango Club for the excellent service, superb food, and strong drinks. The club was shuttered in 1986 due to dwindling membership and rising property values. It was demolished in 1991. (Courtesy of the *Dallas Morning News*.)

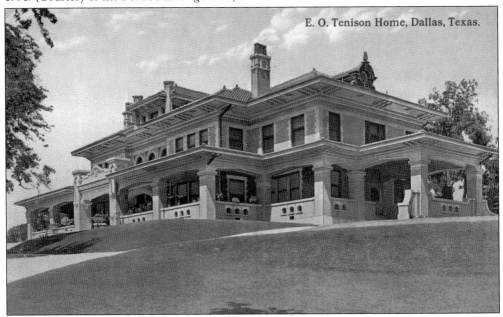

Noted Dallas architect C.D. Hill designed the magnificent Tenison House in 1908. Built for City National Bank president Edward Tenison, the rambling mansion, with its commodious porch and expansive tile roof, was a perfect combination of Mission and Prairie styles. The residence presided over the intersection of Cedar Springs and Turtle Creek Boulevard for less than 40 years until it was demolished in 1947 for an office building. Remnants of the entry and circular drives are still visible. (Courtesy of Dallas Heritage Village.)

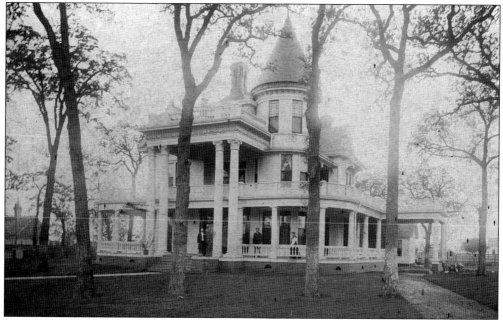

In 1889, William B. Gano built this impressive neoclassical and Queen Anne mansion at the corner of Oak Lawn and Cedar Springs. Stewart and Fuller designed the columned, full-height entry porch structure. Later sold to Col. S.E. Moss, known as the "Lightning Rod Man of Texas," this fantastic structure graced the neighborhood for 40 years before it was leveled in 1929. (Courtesy of the *Dallas Morning News*.)

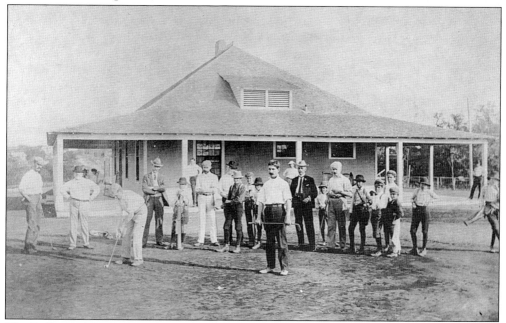

The Dallas Golf and Country Club constructed its first clubhouse on Lemmon Avenue along Turtle Creek in 1897. A subsequent and more substantial structure was built in front of this one, which served until it burned in 1908. The club ultimately moved to Highland Park in 1912. (Courtesy of the *Dallas Morning News*.)

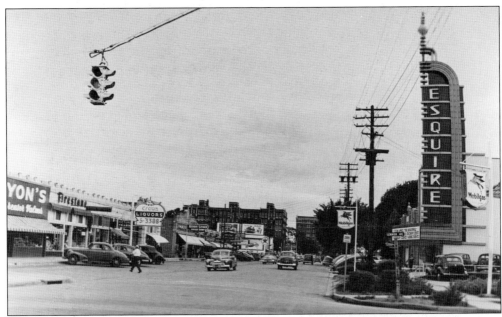

The intersection of Oak Lawn and Lemmon Avenues, shown here in the late 1940s looking southwest, developed as a commercial epicenter for the Oak Lawn neighborhood. The Esquire Theater is shown on the right with the Melrose Hotel (still standing) looming in the background where Oak Lawn Avenue continues and curves at Cedar Springs Road. (Courtesy of the *Dallas Morning News*.)

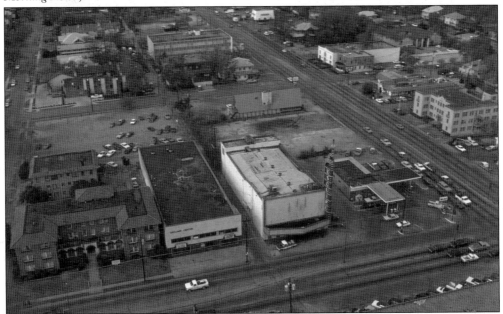

This 1980s aerial of the same intersection looking northwest shows the further commercial encroachment radiating out from either side of Lemmon Avenue into the Oak Lawn residential neighborhoods. The Esquire Theater, along with the neighboring office building and brick apartment buildings along Rawlins Street, would all soon be leveled for commercial and residential redevelopment.

The Esquire Theater, one of Dallas's Art Deco masterpieces, was constructed originally in the 3400 block of Oak Lawn Avenue in 1931 as the Melrose Theater. When the Melrose Theater was sold to the Interstate Theater Corporation in 1947, the building was extensively remodeled and renamed. Featuring a brightly lit marquee, a neon artist's palette, and a distinctive vertical sign that became an instant landmark, the Esquire was sold in the early 1980s. This neighborhood icon was demolished over howls of protest and hurried attempts at rescue in February 1985. The proposed redevelopment never materialized, and the site remains a parking lot. (Courtesy of the *Dallas Morning News*.)

Holy Trinity College, Dallas, Texas.

Commissioned by the Western Province of the Mission (Vincentians) to design a new Catholic college for boys, architect H.A. Overbeck produced plans for a multistoried masonry building situated at the corner of Oak Lawn Avenue and Gilbert Street. Known as Holy Trinity College upon completion in September 1907, the school later operated as the University of Dallas until 1929. Used for a short time as an orphanage, the impressive structure operated as Jesuit High School from 1941 to 1964. The school moved and sold the land, and the site was cleared in 1966. (Courtesy of Dallas Heritage Village.)

The Decorative Center, designed by Jacob Anderson, was a collection of one-story redbrick buildings around a central court. Built in 1954, the center, located on a highly visible piece of Design District property where Oak Lawn Avenue, Hi-Line Drive, and Turtle Creek converge, was taken down for new residential construction in 2008. (Courtesy of Craig Blackmon, FAIA.)

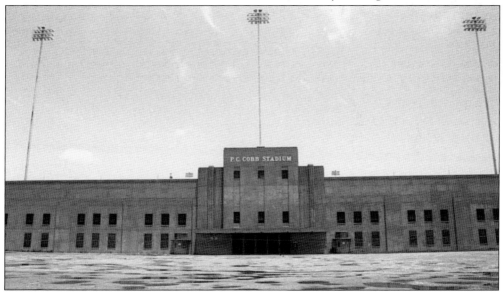

Constructed as a Works Progress Administration project, P.C. Cobb Stadium, originally known as Dal-Hi Stadium, was the premier facility for Dallas Independent School District (DISD) sporting events when it opened at the northeast corner of Stemmons Freeway and Oak Lawn Avenue in 1939. Renamed for a longtime DISD administrator in 1957, the reinforced concrete stadium could seat 22,000 spectators and, at its zenith, hosted over 500 events a year. In 1985, the stadium and surround 25-acre site was sold for the construction of Trammel Crow's InfoMart. (Courtesy of the *Dallas Morning News.*)

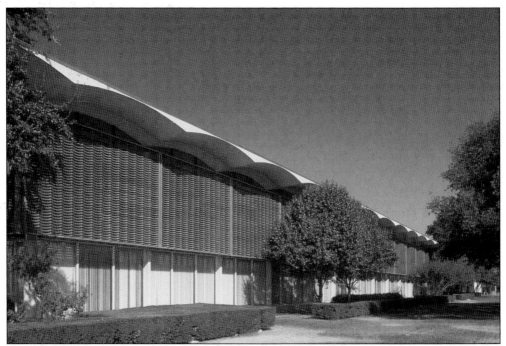

Beaumont architects Pitts Phelps & White designed the simple yet elegant Coca-Cola Bottling Plant in 1963. The two-story main facade, facing Lemmon Avenue, featured a graceful curved arched fascia and metal brise soleil. The entire site, along with adjacent buildings at the corner of Inwood Road, was quietly cleared in 2005 for big-box commercial development. (Courtesy of Craig Blackmon, FAIA.)

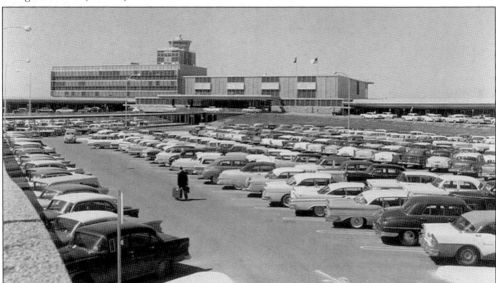

Established by the Army as a flying installation in 1917, Love Field was purchased by the city in 1928, with the first terminal for commercial air passengers completed in 1929. That terminal was replaced with the current but heavily modified 1958 terminal that at the time of opening featured three concourses with moving sidewalks and the Luau Room restaurant above the main lobby. (Courtesy of the *Dallas Morning News*.)

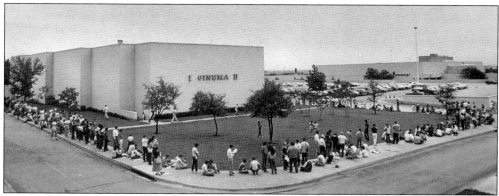

The crowd in this 1983 image has lined up around NorthPark Cinema I and II for tickets to view *Return of the Jedi*. Opened in 1965, NorthPark Cinema I and II was Dallas's first twin cinema and was considered one of the best movie theaters in the country. With modern white brick architecture matching the neighboring NorthPark shopping center, the theater continued to please audiences with its incredible sound, perfect projection, and flawless customer service until October 1998. The complex was taken down in March 2001 for an expansion of NorthPark Center. (Courtesy of the *Dallas Morning News*.)

Kip's Big Boy, located on Northwest Highway and Hillcrest Avenue, was one of Dallas's best examples of googie architecture when built in 1964. Heavily influenced by Southern California firm Armet & Davis, architect Carter Minor designed an instant landmark that featured expansive panes of glass, octagon-shaped sunscreens on the west facade, and a roof that seemed to float in air. The site was sold for commercial redevelopment, and the building, along with the well-known sign, was leveled in 2005. (Courtesy of Preservation Dallas.)

Jerry Bywaters, one of the founders of the 1930s Dallas Regionalist movement, commissioned famed architect O'Neil Ford to construct a new house on his Bluffview property. Located at 4715 Watauga Road and built to compliment a smaller studio on the site constructed in 1929, the compound was the hub of the Dallas artistic community for decades. The site was cleared unexpectedly in 2003 for new residential construction. (Courtesy of Preservation Dallas.)

Built in 1888 and originally part of the Renner community before annexation in 1977, the Jackson Farmstead was located on Dickerson Road in far North Dallas. Despite discussions of historic designation and a last-minute attempt at moving the rambling, three-story structure, the house was demolished and the large parcel of land developed into tract housing in the early 1990s.

Boasting over 1.2 million square feet of leasable space and featuring an indoor ice-skating and children's play area with a two-story chiming clock, Prestonwood Town Center was the ultimate in shopping experiences when it opened in 1979. Located at Beltline Road and Montfort Drive close to the Dallas city limits with Addison and Richardson, Prestonwood Mall, as it was informally called, thrived until newer and more upscale shopping centers opened nearby. The last anchor store closed in 1999, and the entire site was cleared in 2004 for a new open-air shopping district. (Courtesy of the *Dallas Morning News*.)

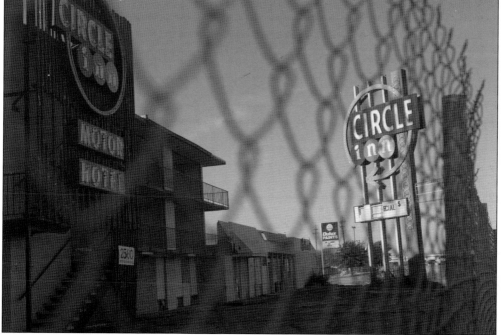

Motorists driving into Dallas from Denton and other points north always knew they had arrived in town when they passed the Circle Inn Motor Hotel, located where Northwest Highway, Denton Drive, and Harry Hines Boulevard converged. Built in 1959, the Circle Inn was famous for its 50-foot flashing neon sign. Although well maintained for decades after its opening, the property deteriorated over the years and was finally torn down in 2006 for light rail construction. The iconic sign was dismantled and saved by a professional sign maker. (Courtesy of the *Dallas Morning News*.)

Discover Thousands of Local History Books Featuring Millions of Vintage Images

Arcadia Publishing, the leading local history publisher in the United States, is committed to making history accessible and meaningful through publishing books that celebrate and preserve the heritage of America's people and places.

Find more books like this at
www.arcadiapublishing.com

Search for your hometown history, your old stomping grounds, and even your favorite sports team.

Consistent with our mission to preserve history on a local level, this book was printed in South Carolina on American-made paper and manufactured entirely in the United States. Products carrying the accredited Forest Stewardship Council (FSC) label are printed on 100 percent FSC-certified paper.

MADE IN THE